P9-CAY-511

The Campus History Series

SUFFOLK UNIVERSITY

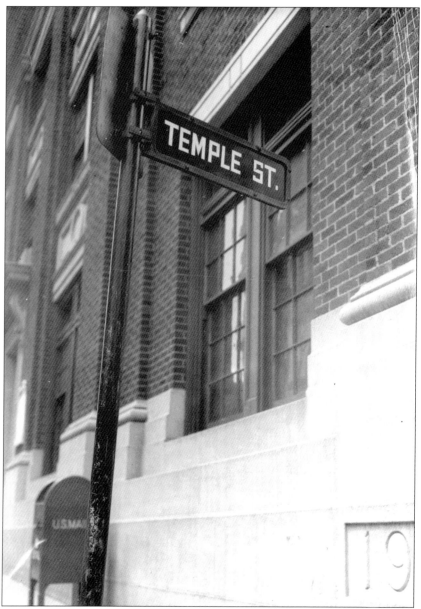

Temple Street, on Boston's historic Beacon Hill, has been Suffolk University's home for much of its history. The university was founded by Gleason Archer as Archer's Evening Law School on September 19, 1906. Archer moved the school from his home in Roxbury to his law offices in downtown Boston in the fall of 1907 and renamed it the Suffolk School of Law. After a period of renting space, Archer purchased the first campus building on Beacon Hill in 1914, and six years later constructed a permanent home for the institution at 20 Derne Street. Suffolk University's home campus now has facilities in 14 buildings in downtown Boston, as well as campuses in Madrid and West Africa.

On the cover: Freshmen of the Suffolk School of Law gather for a portrait in 1911. (Courtesy of Suffolk University Archives.)

The Campus History Series

SUFFOLK UNIVERSITY

DAVID L. ROBBINS, PH.D.

ARCADIA
PUBLISHING

Copyright © 2006 by Suffolk University
ISBN 0-7385-4516-3

Published by Arcadia Publishing
Charleston SC, Chicago IL, Portsmouth NH, San Francisco CA

Printed in the United States of America

Library of Congress Catalog Card Number: 2006921820

For all general information contact Arcadia Publishing at:
Telephone 843-853-2070
Fax 843-853-0044
E-mail sales@arcadiapublishing.com
For customer service and orders:
Toll-Free 1-888-313-2665

Visit us on the Internet at www.arcadiapublishing.com

The shape that this volume has taken is due, in incalculable and incomparable degrees, to the contributions made by the following: Robert Allison, Susan Atherton, Beth Bower, Roxana Canales, John Cavanagh, Julia Collins, George Comeau, John Deliso, Karen Decilio, Marguerite Dennis, Nancy Kelleher, Michael Madden, Teri Malionek, Jessica Merenda, Patricia Meservey, Jim Nelson, William O'Neill, Marc Perlin, Rebecca Rudolph, Rosemarie Sansone, David Sargent, Nancy Stoll, and Midge Wilcke. For the visual materials that are its basis, special recognition is due to the Suffolk University Archives, Minnesota Law Library, John Gillooly, John Gillooly Jr., David Lancaster, Bill Walcott, Brian Phillips, and generations of photographers who have participated in documenting the life of Suffolk University and its communities.

CONTENTS

FOREWORD

Suffolk University looks with pride on the accomplishments of its first 100 years through this collection of photographs. They show how the university, since its inception, has worked to build better lives through educational opportunity.

In 1906, it was the workers and immigrants of Boston who lacked opportunity, and Gleason Archer opened new doors to them through education. Soon a diverse student body of men and women of all races, religions, and economic backgrounds were able to reach their highest potential in Suffolk University's academic community.

Suffolk University has touched many lives since those early days, and the remarkable men and women who have passed through our halls have played an important role in making us a leading urban university.

Today the university attracts students from across the nation and around the world. Yet we continue to make higher education accessible to capable students who might otherwise be left behind. African students seeking an American-style education learn from Suffolk professors at our Dakar, Senegal, campus. Creative partnerships with institutions here and abroad serve both to ease the entry into the university community and expand academic horizons. And scholarship assistance is provided so that cost won't deter able students.

Even as Suffolk University augments its facilities and works to stay on the cutting edge of knowledge and technology in its second century, some things will never change. The university remains grounded in Gleason Archer's mission of access and opportunity for all deserving students, regardless of race, religion, ethnicity, gender, or sexual orientation. We still practice what he referred to as "the gospel of self-help and hard work."

Suffolk University always will remain a caring community, with every member of the faculty, staff, and administration dedicated to educating and supporting students. And those students, like generations of Suffolk students before them, will take their places as successful and conscientious citizens of the world.

David J. Sargent
President
Suffolk University

INTRODUCTION

"History has demonstrated that the great leaders of every age were, almost without exception, born in poverty, denied educational advantages in boyhood, and obliged to educate themselves at odd moments while doing a man's work in the world. The same immutable principle is in operation today—the earnest souls who now toil in the evening schools to fit themselves for life will be found in the front ranks of our civilization of tomorrow."

—Gleason L. Archer, 1923

Suffolk University grew from humble beginnings in the Roxbury living room of Gleason L. Archer, a young lawyer who had worked his way through high school and college. This book uses photographs from the Suffolk University Archives to illustrate the historical journey from Archer's hopeful beginnings in his home to the realization of his dream through the global institution that is Suffolk University today.

While Archer was still a student, a chance encounter brought him together with George A. Frost, a benefactor who loaned him money to pursue the study of law, asking only that Archer pass along the favor. In 1906, Archer opened the Suffolk School of Law, a night school established to "serve ambitious young men who are obliged to work for a living while studying law." He believed that the growing waves of immigrants who came to America's shores should be given the same opportunities that had been the privilege of the wealthy few.

Archer soon moved the school into his downtown law offices, and in 1908 machinist and Archer student Roland E. Brown passed the bar. News of Brown's achievement led to a boost in registration, so Archer gave up his law practice to devote himself full time to the Suffolk School of Law.

By 1930, Archer had built Suffolk into one of the largest law schools in the country.

The College of Liberal Arts—later renamed the College of Arts and Sciences—was founded in 1934 in response to the recommended standard that law students attend two years of college and because Archer wanted to create "a great evening university" that working people could afford.

Three years later, in 1937, the College of Business Administration, now the Sawyer Business School, was established. It offered the possibility of the extension of intellectual analysis into the field of business.

The three academic units were incorporated as Suffolk University in 1937, and over the years the university expanded from its night-school format to incorporate a range of full- and part-time programs.

Along with a growing array of academic programs came a spirit of community and a lively campus atmosphere, as seen in photographs throughout the book. Athletics, dances, and clubs served to draw students together and give them a sense of belonging. The university also became known as a student-centered school where faculty and administrators would take the time to help students aim high and reach their goals.

The College of Arts and Sciences now consists of 17 academic departments, including the New England School of Art and Design. The college offers more than 50 programs of specialized study, at the baccalaureate, master, and doctoral levels. In small classes where they receive personalized attention from renowned teacher-scholars, students gain a world class education. Through innovative programming, such as the Distinguished Visiting Scholars Program, the college brings some of the most formidable minds in the world today into the university community.

The Sawyer Business School's mission of preparing successful leaders in the practice of global business and public service is met through offering nine undergraduate majors and 23 graduate degrees. Global leadership is at the center of the business school's curriculum. Students receive a strong academic preparation in business fundamentals, develop strong networking skills, improve leadership abilities, and learn to embrace innovative thinking.

The law school offers juris doctor and master of laws degrees. Its expansive curriculum combines a strong academic foundation with expertise in an array of specialty areas. Nationally known faculty and a range of practical experiences provide superior preparation for law practice in the 21st century. The law school also is bringing legal education to the wider world through a pioneering partnership with the Massachusetts Supreme Judicial Court, broadcasting its oral arguments live through the Suffolk University Law School Web site.

The university community extends far beyond its schools and campuses, with a network of more than 55,000 alumni in chapters across the country and abroad.

Today Suffolk University is a global institution. The onetime commuter school now has two residence halls, allowing resident students fully to realize the academic and cultural promise of their Beacon Hill surroundings. Suffolk's classrooms, libraries, and offices are housed in 14 buildings in downtown Boston.

In 1995, the university's first international campus was opened in Madrid. A second international campus, in Dakar, Senegal, opened in 1999 and a year-round Prague program in 2004. Each school also has formed working relationships with a wide range of institutions abroad.

Satellite campuses have been established in Massachusetts at Barnstable, North Andover, and Franklin. And students also may enroll in online master of business administration classes through the business school.

One

ARCHER'S STARRY REACH

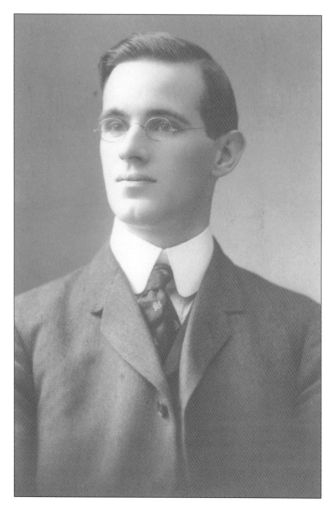

As a newly minted attorney in 1906, Gleason Archer joined the Boston law firm of Carver and Blodgett. But he wanted to do more than practice; he intended to offer other young men the opportunity to pursue the study of law.

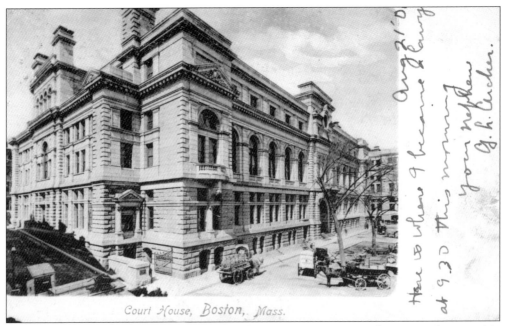

Court House, Boston, Mass.

"This is where I became a lawyer at 9:30 this morning," writes Gleason Archer on this postcard to his Maine relatives on August 21, 1906. The card depicts the Suffolk County Court House in Pemberton Square, Boston. Today one can see the Suffolk University campus from the newly restored building, now called the John Adams Courthouse.

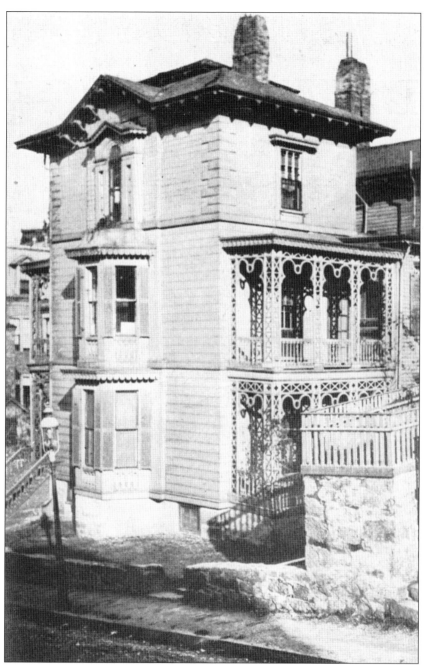

Archer found both a home and classroom space in this house at 6 Alpine Street, Roxbury, where he rented the ground floor. Signs for Archer's Evening Law School were displayed in the bay window, and the first class was held in the living room on September 19, 1906. To stretch his budget, Archer designed and built the classroom furniture, but the varnish had not set properly, and students were sticking to the chairs that first evening. "Thoughts of damage suits and certainly damaged suits flitted through my mind, but I forged desperately ahead with my lecture," wrote Archer afterwards. But a student distributed newspapers to cover the seats, and the first lecture was a success.

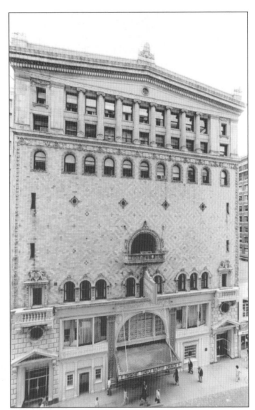

The Tremont Temple Baptist Church on Tremont Street, Boston, was the site of Suffolk School of Law classes from 1909 until 1914. The university revisits the historic building for special events to this day.

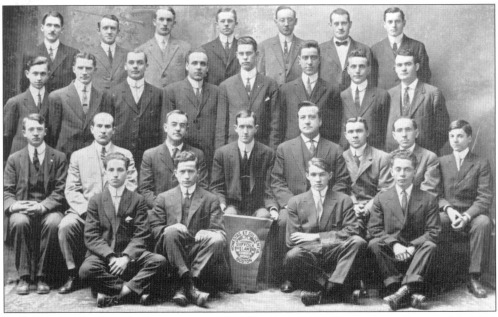

Suffolk School of Law had grown considerably five years after its founding, as this 1911 photograph of freshmen attests. A handful of students initially joined Archer's Evening Law School, but enrollment began to build as soon as Archer student Roland E. Brown passed the bar in 1908.

This building at 45 Mount Vernon Street, Boston, was the home of Suffolk Law School beginning in 1914—a momentous year, as the school received its degree-granting charter. The 1914 charter also resulted in a third name change, to Suffolk Law School.

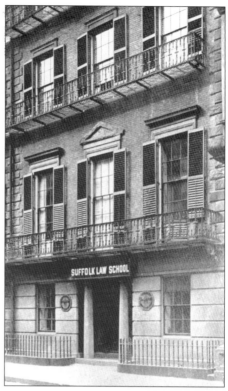

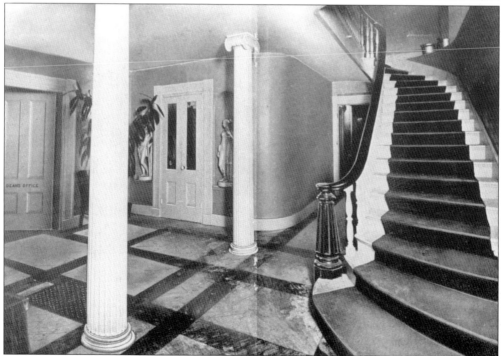

Shown here is the foyer of Suffolk Law School at 45 Mount Vernon Street, with Dean Archer's office to the left. Suffolk Law School occupied this building from 1914 to 1920.

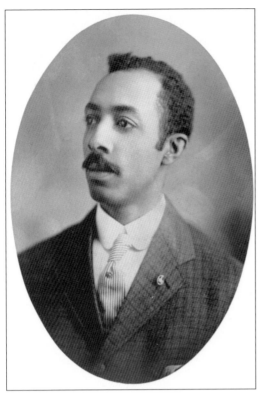

Many of the early students who attended Archer's Evening Law School were immigrant working class and minorities. Thomas Vreeland Jones was one of the first African Americans to graduate from Suffolk Law School, in 1915. A scholarship in his name has been established at Suffolk University Law School by family and friends.

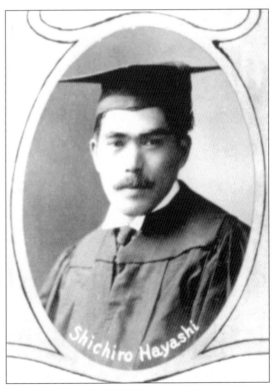

Suffolk's first Asian graduate, Shichiro Hayashi, is shown here in his 1922 graduation photograph.

This view is of Temple and Derne Streets in 1898, from the newly built stone steps to the Massachusetts State House grounds. The Archer Building now stands on that corner. The spires of the First Methodist Church (formerly Grace Episcopal Church) rise in the background.

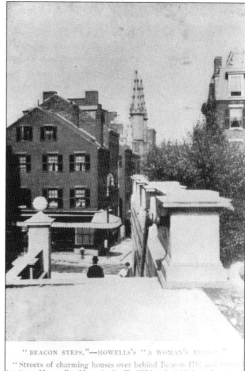

" BEACON STEPS."—HOWELLS's "A WOMAN'S REASON."

" Streets of charming houses over behind Beacon Hill and below the State House."—*Mrs. A. D. T. Whitney's "Hitherto."*

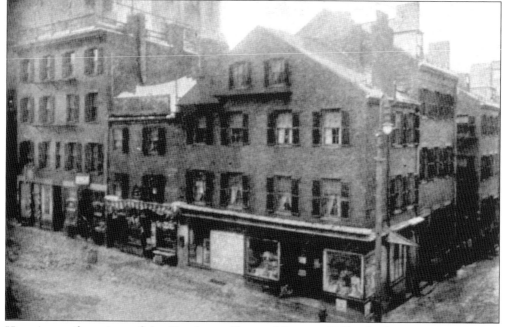

Here is another view of the Northeast Slope of Beacon Hill, which was an immigrant neighborhood in the early 20th century. These buildings at the corner of Temple and Derne Streets were demolished in 1920 and replaced by the Suffolk Law School Building at 20 Derne Street. Gleason Archer took pains to help displaced residents find new homes.

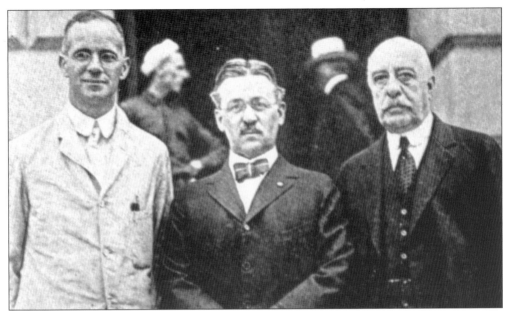

The building committee for Suffolk's first edifice strikes a proud pose at the August 4, 1920, cornerstone-laying ceremony. The committee was comprised of Dean Archer (left); James M. Swift (center), longtime trustee; and George A. Frost, the benefactor who put Archer through Boston University Law School and inspired him to share his good fortune with others by founding Suffolk.

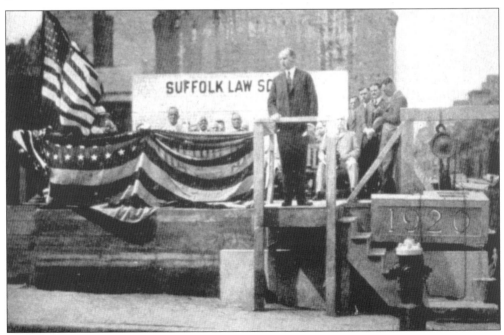

Massachusetts governor Calvin Coolidge lays the cornerstone of the Archer Building on August 4, 1920. This was the governor's first public address after his nomination for the vice presidency of the United States. "Silent Cal" would later serve as vice president and president of the United States.

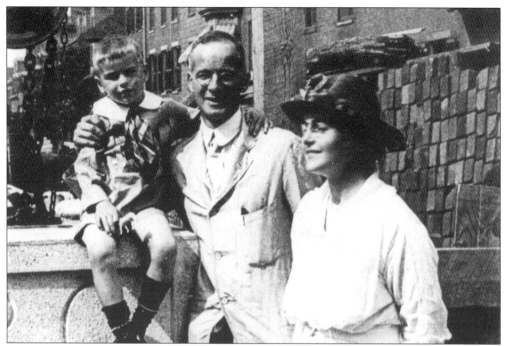

Gleason Archer Jr. perches on the cornerstone officially to be lain later that day. Archer's youngest child, who would become an eminent theologian, sits alongside his father and mother, Elizabeth Glenn Archer.

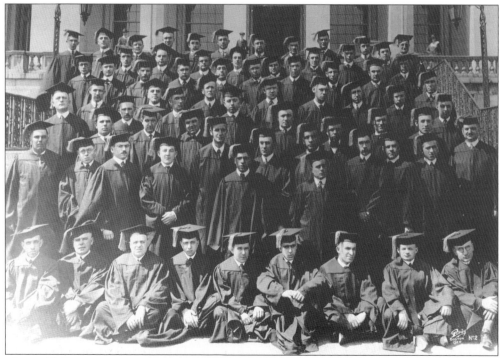

The Suffolk Law School class of 1920 is pictured here on the steps of the neighboring Massachusetts State House.

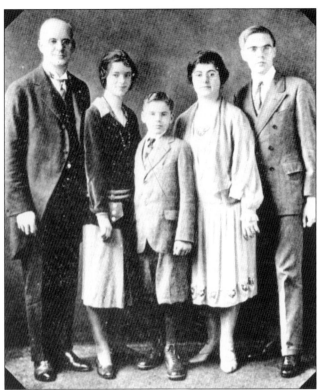

Dean Archer and Elizabeth Glenn Archer are pictured with their children in October 1926. The eldest, Allan, is at right; Marian, the middle child and only daughter, and Gleason Jr., the youngest, stand between their parents.

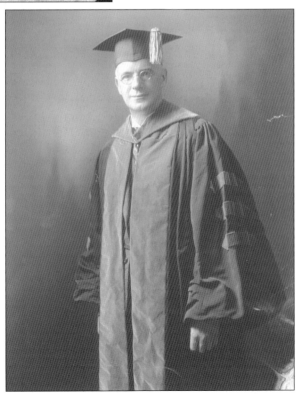

Shown here is Gleason Archer in academic regalia.

Gleason Archer became a household name among those with radios through his nationwide NBC network broadcasts on law and colonial history. Here he is at the microphone at WEAF in New York, where the broadcasts originated.

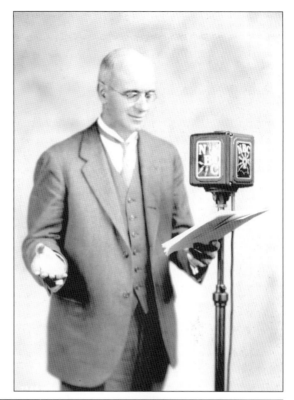

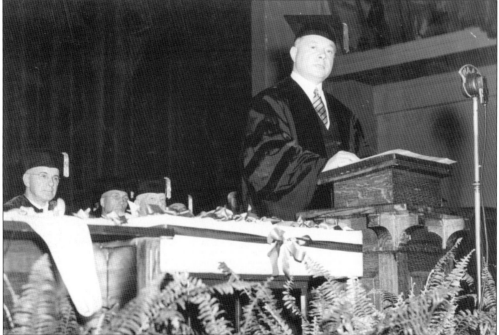

RCA chairman David Sarnoff, for whom Gleason Archer aired his historical and legal broadcasts on the NBC radio network, delivers Suffolk University's commencement address in 1939.

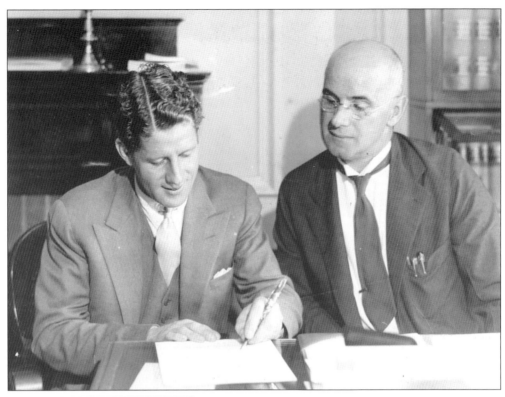

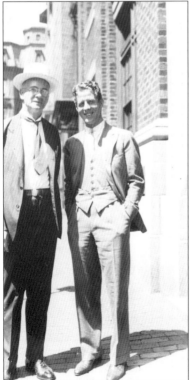

Popular crooner Rudy Vallee enrolls in Suffolk Law School in 1932, under Dean Archer's watchful eye. The two men both hailed from Maine and became great friends during Archer's broadcasting career. For the publicity that it would give the school, Vallee agreed to enroll, just as he later consented to be listed as a trustee and as an instructor in the College of Journalism.

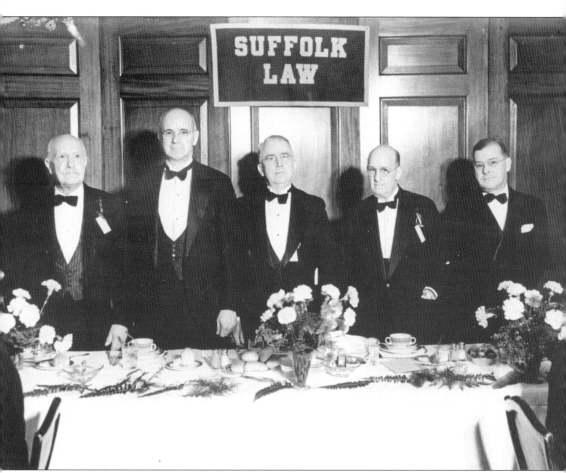

Trustees' chair Thomas J. Boynton, President Gleason Archer, trustee John Shepard of the Yankee Network, and colleagues are pictured here at a testimonial dinner for Archer immediately following the creation of Suffolk University in 1937. The university incorporated the College of Liberal Arts, founded in 1934, the College of Business Administration, founded in 1937, and the newly renamed Suffolk University Law School.

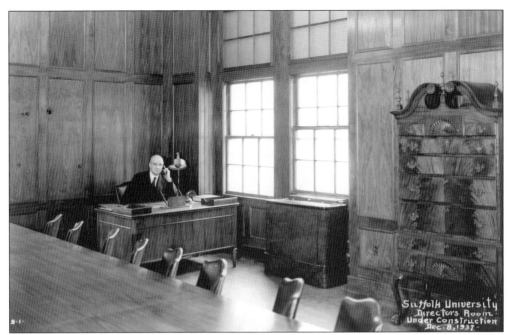

Gleason Archer is at his desk in December 1937 in the directors' room complex on the newly constructed fourth floor of the University Building, formerly the Law School building, at 20 Derne Street.

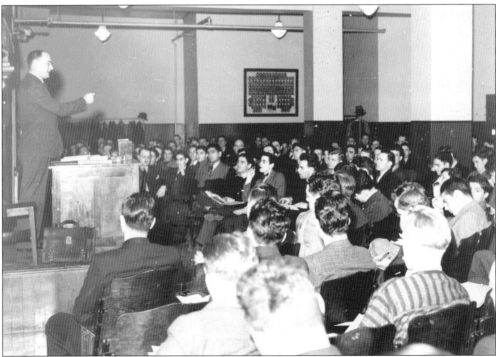

Professor Stinchfield lectures on agency to first-year Suffolk University Law School students in 1938.

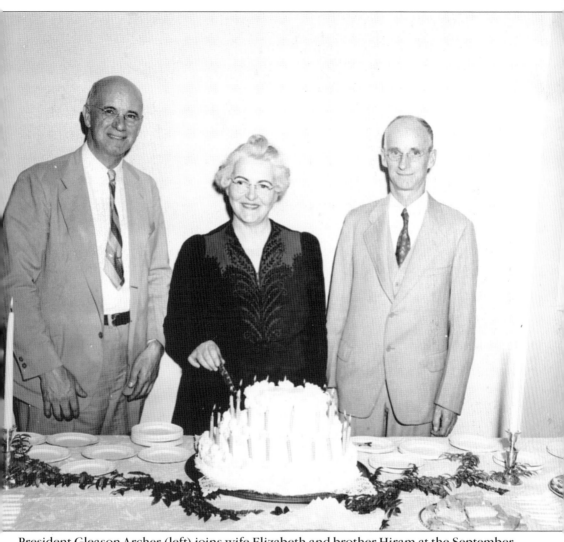

President Gleason Archer (left) joins wife Elizabeth and brother Hiram at the September 19, 1941, gala celebrating the 35th anniversary of Suffolk University's founding.

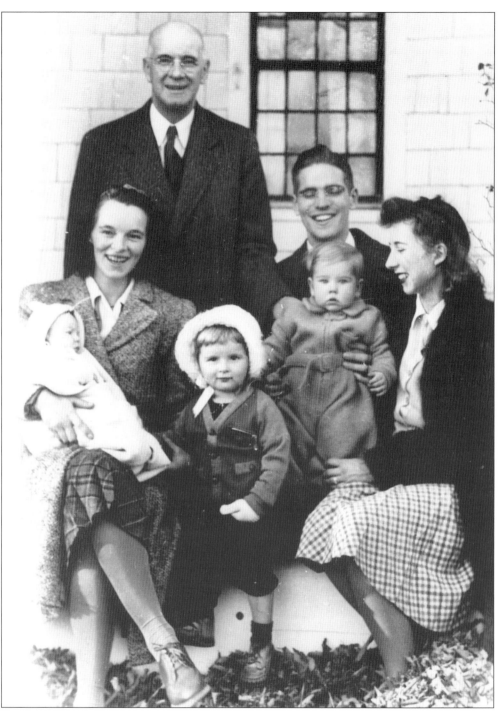

Pictured here is the Archer family on the front porch of President Archer's home at his compound on Stetson Road, Norwell, on December 20, 1941. Shown here are President Archer, standing; Marian Archer MacDonald, holding Joyce; Gleason Jr., holding Gleason L. Archer III; his wife, Virginia Atkinson Archer; and, at center, Faith MacDonald.

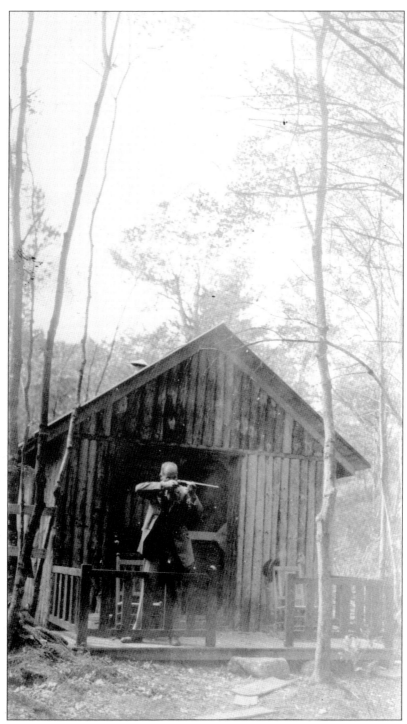

Gleason Archer takes aim at the Reverie, the log cabin that Archer built by hand on his Norwell estate in 1925. The retreat was named by Dallas Lore Sharp, a popular professor of English who had taught Archer at Boston University and who remained until his death in 1929 one of Archer's few close friends.

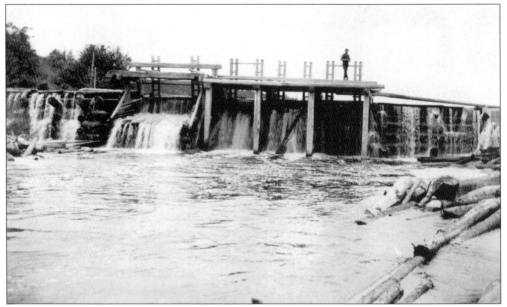

Gleason Archer, founder and president of Suffolk University and a nationally known radio commentator, had come a long way from his roots in Maine. He grew up in Hancock County Plantation No.33, known "by courtesy of the Post Office Department," as Great Pond. Here is the Great Pond Dam, which helped give rise to the area's popular name. Today the plantation remains sparsely populated, with about one resident per square mile.

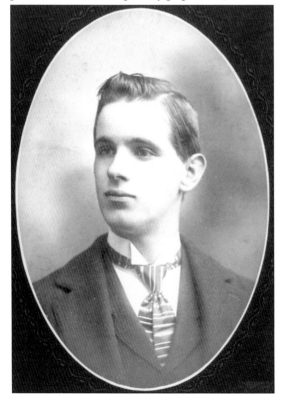

This is Gleason Archer as a second-year student at Sabattus High School, Maine, 1899. His life had been changed through education, and he dedicated his life to creating educational opportunity for others.

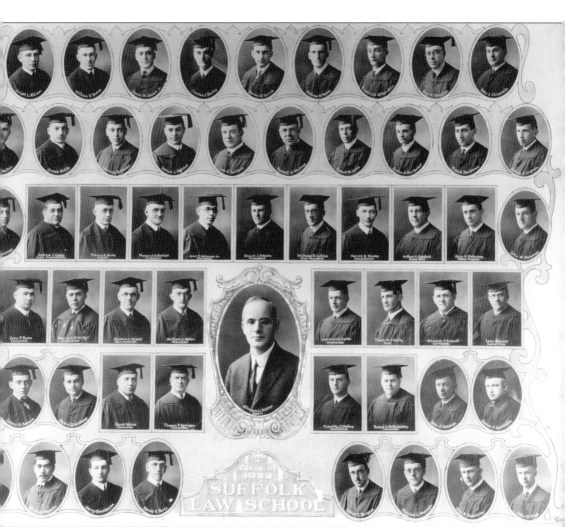

Many of the people whose lives were changed through Archer's dedication began to reap immediate benefits from the newly expanded law school on Beacon Hill. This portrait of the class of 1922 represents some of the legions of students who would continue to attend Suffolk University.

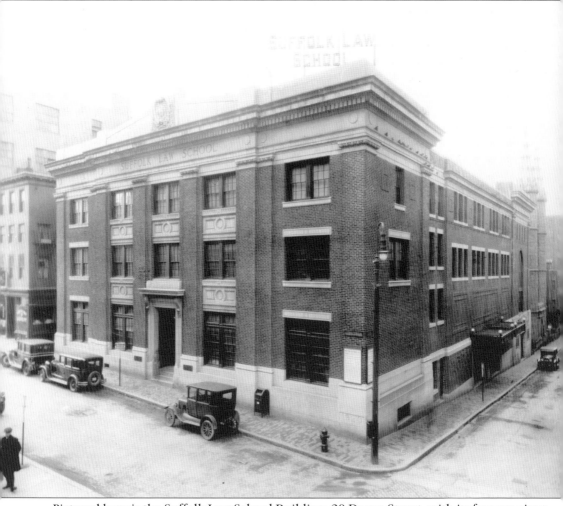

Pictured here is the Suffolk Law School Building, 20 Derne Street, with its famous giant electric sign in 1926. Legend has it that the sign was oriented to create consternation in the neighboring Massachusetts State House among Harvard University partisans who shrilly accused Archer's law school of trying "to make cart horses into trotters."

Two

THE UNIVERSITY
TAKES SHAPE

This stately building at 59 Hancock Street, at the intersection of Myrtle Street, served as the home of the Suffolk College of Liberal Arts from 1935 until the addition of two floors to the University Building at 20 Derne Street in 1937.

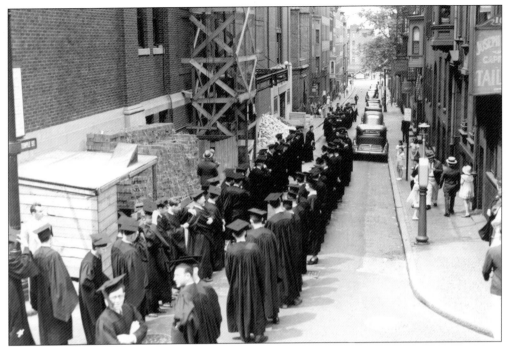

Degree candidates line Temple Street on the university's first baccalaureate Sunday, June 13, 1937. Services were at the First Methodist Church on Temple Street. Construction materials for the University Building addition are stacked nearby.

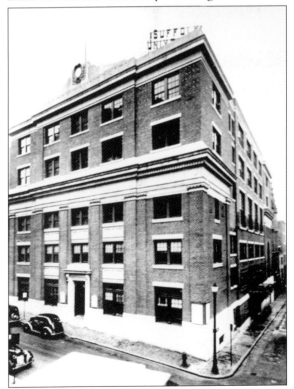

This is the reconstructed University Building at 20 Derne Street, following the addition of two floors in 1937 and replacement of the old Suffolk Law School electric sign with a new one reading Suffolk University. The sign endured until 1946.

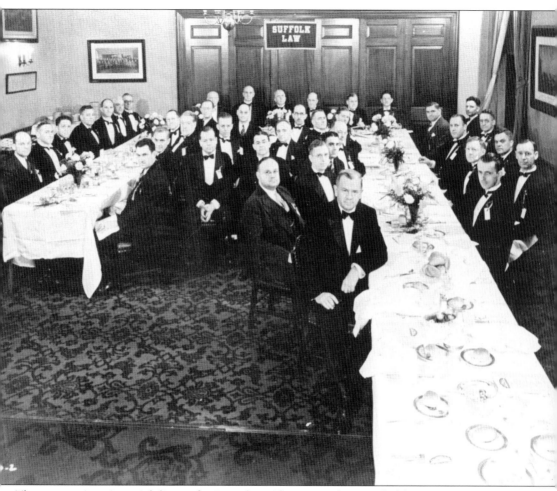

The trustees' testimonial dinner for President Gleason Archer was held in June 1937, one month after incorporation and chartering of the new Suffolk University.

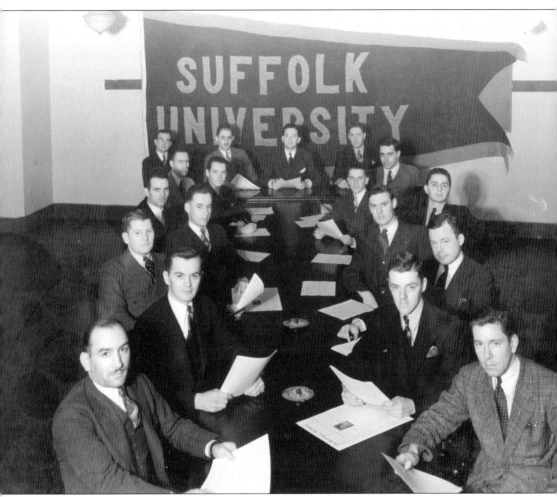

The Suffolk University Student Council was made up mostly of law students, with a smattering of undergraduates, in 1939–1940.

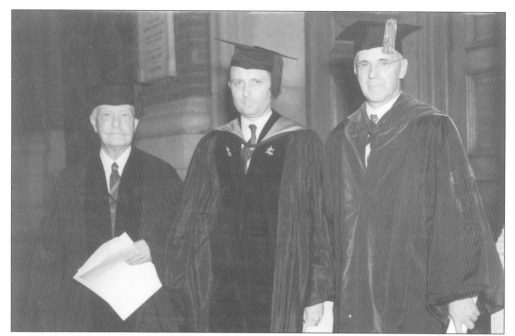

Longtime trustees' chair Thomas J. Boynton; the college's first dean, Donald W. Miller; and President Archer attend the 1937 commencement in Ford Hall on Beacon Hill. The building was demolished in 1970, but its name lives on in the Ford Hall Forum, the nation's oldest public lecture series, which began in 1908.

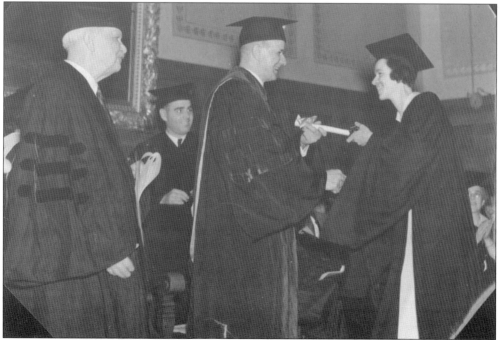

President Archer presents a Suffolk Law School diploma to his daughter, Marian Archer MacDonald, the first woman graduate, in June 1937. Her success convinced Archer to open the university's doors to other women. Board chair Boynton stands at left.

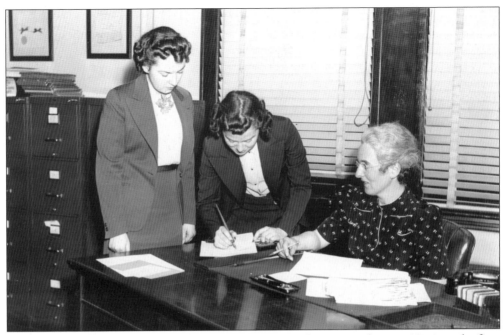

Registrar Carrolla Bryant registers Eleanor Frances and Frances Eleanor O'Brien, the first twins to enroll in the pre-legal course at the College of Liberal Arts, September 1940.

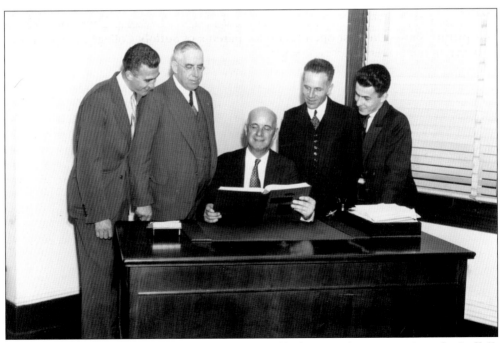

President Archer with the Russos, left, and the Gallaghers, as the sons register for Suffolk Law School, following in the footsteps of their alumni fathers, 1940.

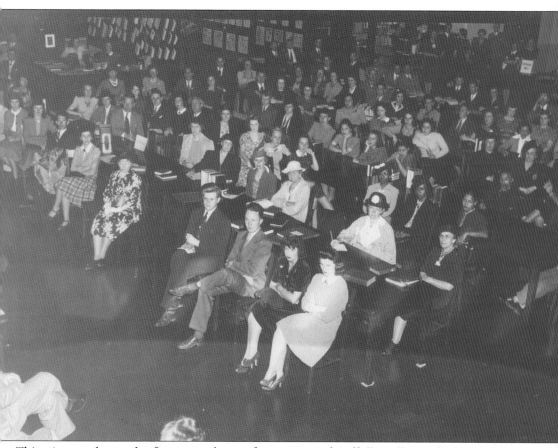

This picture shows the first open house for parents of Suffolk College of Liberal Arts students, in the university library, September 14, 1940.

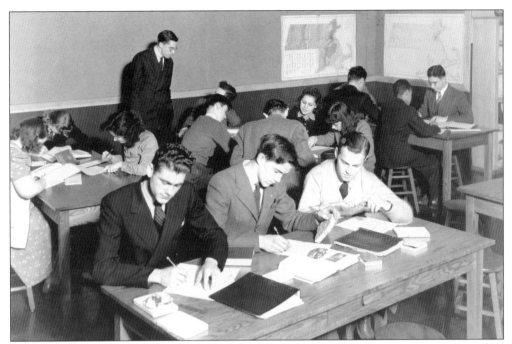

This is the morning section of the general geology class at Suffolk College of Liberal Arts, January 1941.

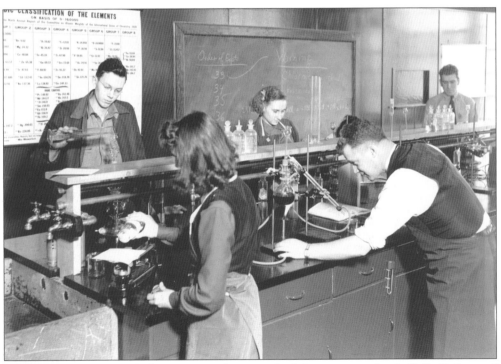

Shown here are general chemistry students in the laboratory at the Suffolk College of Liberal Arts, January 1941.

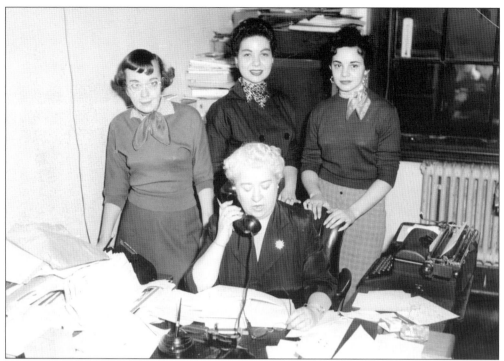

Suffolk's beloved "Dotty Mac," Dorothy M. McNamara, served the university for 47 years as stenographer, bursar (1941–1964), and alumni director until 1974.

Robert J. Munce was Suffolk College of Liberal Arts dean (1949–1956), third Suffolk University president (1954–1960), and Suffolk University's only chancellor (1960–1964).

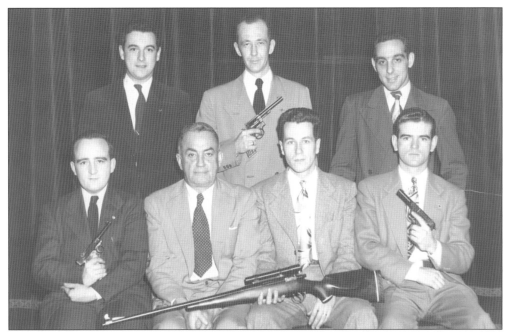

The Suffolk University Rifle and Pistol Club is pictured here in 1950. Shooting never became a varsity sport at Suffolk, but with a student body composed overwhelmingly of World War II veterans between 1946 and 1955, the institution provided an organization for firearms aficionados on campus.

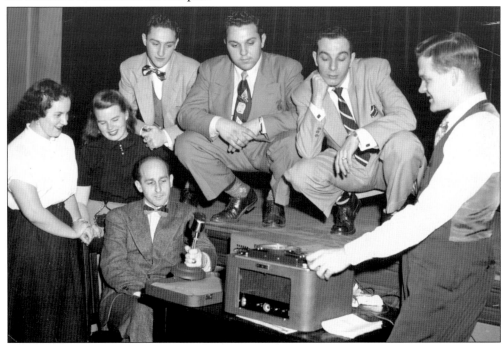

The Suffolk University Radio Workshop was the university's first venture in student broadcasting; its debut came in November 1948 on station WVOM. Shown here is an early picture of a student recording session, Suffolk Theatre, around 1948.

Here is a *Suffolk Journal* reporter at work. Journalism was a featured undergraduate discipline at Suffolk in the 1940s and 1950s, and the *Suffolk Journal* newspaper—founded in 1936 and published continuously since that time—was the college's first student publication.

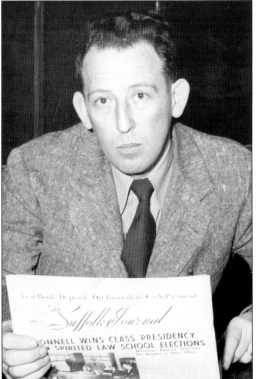

Suffolk students have depended on the *Suffolk Journal* for university news since 1936. Here the new law school class president learns, via the *Suffolk Journal*, of his election in February 1954.

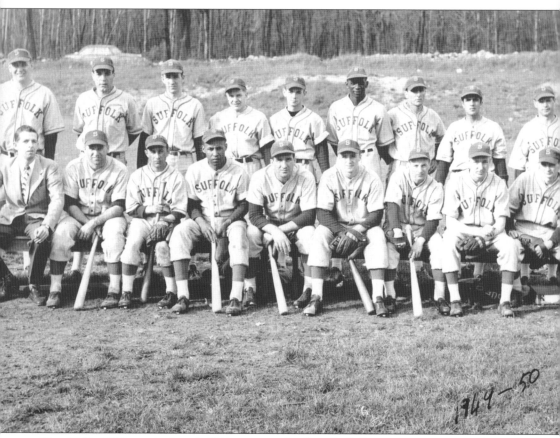

The 1949–1950 varsity baseball Rams was the first Suffolk University team to bear that nickname. In April 1950, a contest run by the Varsity Club and the *Suffolk Journal* came up with the new name for Suffolk athletic teams, which previously had been known as the Royals or the Judges.

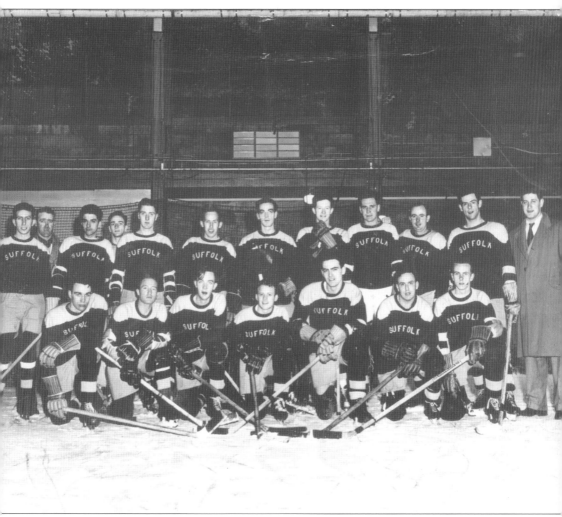

Pictured here is Suffolk's first ice hockey team. Hockey was introduced at Suffolk in 1946, with former Harvard University star Malcolm Donahue as coach. After being dropped as a varsity sport in 1953, it was reinstated in 1980.

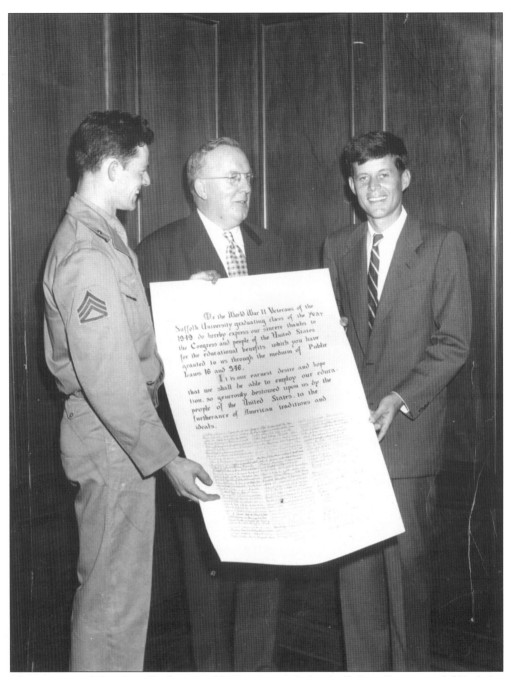

The passing of the GI Bill after World War II saved the Suffolk colleges, and filled the law school once again. Here senior class president Carroll P. Sheehan (1949) and Suffolk president Walter M. Burse present Congress, in the person of U.S. representative John F. Kennedy, with a petition of gratitude, 1949.

Frank L. Simpson became dean of the law school in 1942, succeeding Gleason Archer, who remained president and treasurer. The law school began offering daytime classes the following year.

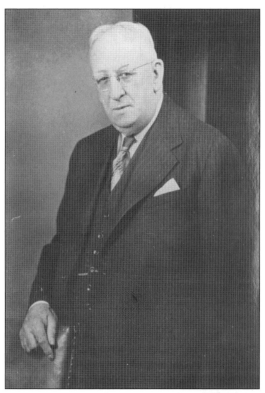

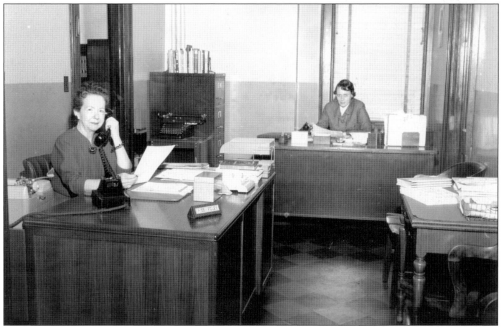

Catherine Judge, rear, was the first law school registrar, joining the university in 1955. She was the only woman to graduate with the law school class of 1957; she earned her master of laws in 1960 and became the law school's first woman professor in 1966. Judge celebrated her 50th anniversary as an active Suffolk University employee in 2005.

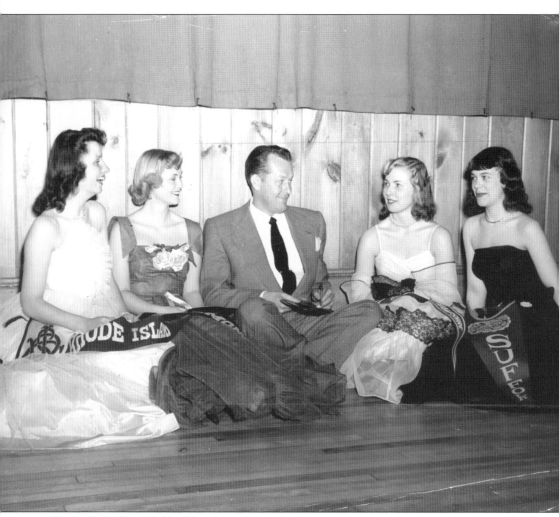

Miss Suffolk (far right), with other campus beauty queens, meets crooner and heartthrob Vaughn Monroe in 1948. The Women's Association of Suffolk University (WASU), founded in 1947, was the school's first women's organization. In addition to service functions, the organization ran a Miss Suffolk contest from 1947 through 1969.

Three

THE GROWTH
OF OPPORTUNITY

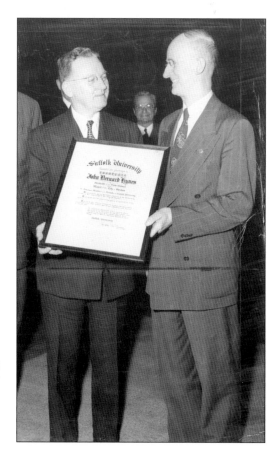

Suffolk alumnus John B. Hynes receives
congratulations from Suffolk University
on being elected mayor of Boston,
1950. As the university matured, many
of its alumni gained prominence,
particularly in public service.

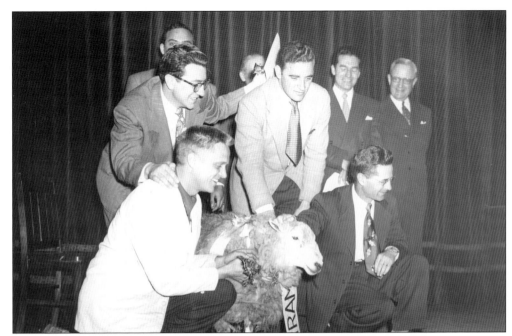

To celebrate the 1950 athletics teams' name change to the Rams, a university mascot—Hiram the Ram—was acquired, and for an entire year the *Suffolk Journal* was renamed the *Rambler.* Pictured here (front, left to right) are Clifton Tatro, Michael Linquata, Hiram I (ram), Charles Tsapatsaris, and athletics director Charles Law.

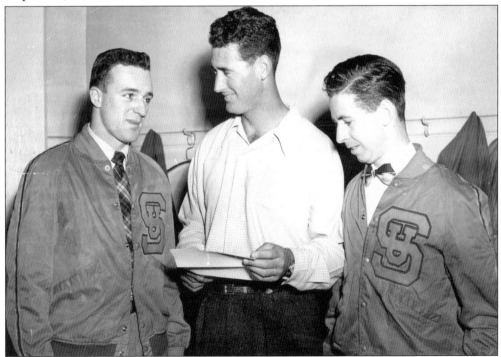

Red Sox slugger Ted Williams receives a warm welcome at the Suffolk Varsity Club in 1950. Seniors Dick Conway and Don Shea flank the Splendid Splinter.

Shown here is Suffolk University's first undergraduate women's basketball team, 1951–1952. This was an "unofficial" team; women's basketball did not become a varsity sport at Suffolk until 1980.

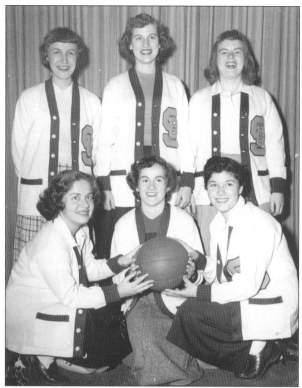

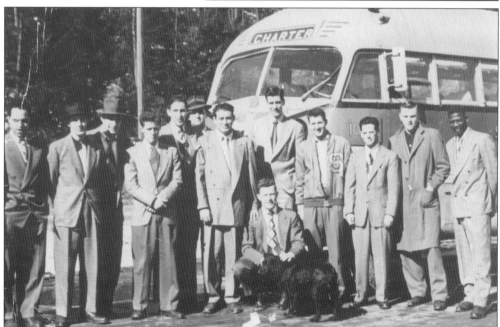

With nary a field, a field house, nor a gymnasium at the university, Suffolk athletics teams played only away games from 1946 until 1991, when the gymnasium was opened in the new Ridgeway Building. For a time, these Suffolk teams were even known as the Ramblers. Pictured with coach Charlie Law and the ever-present team bus is the 1950 basketball squad.

Shown here are student high jinks from the early 1950s, when men overwhelmingly outnumbered women in the college. At the bottom right is classic television comedy writer Mike Marmer, B.S.J., '51, who worked with Milton Berle, Ernie Kovacs, Steve Allen, the Smothers brothers, and Carol Burnett, among many others.

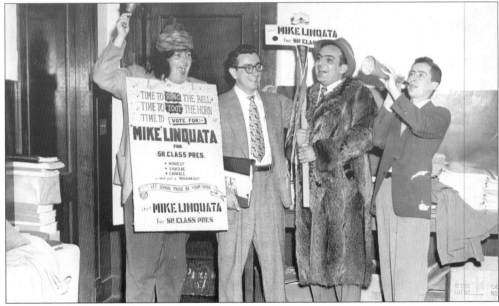

Michael L. Linquata conducted a vigorous, and successful, campaign in 1949 for the presidency of the senior class; his pledge was better parking facilities for Suffolk University students. Shown here from left to right are Francis O'Neill, candidate Linquata, Fiore Masse, and Barton Krinsky.

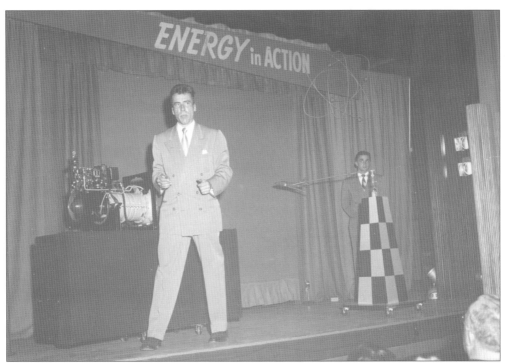

Pictured here is the "Energy in Action" science demonstration at Suffolk Theatre during the 1950s.

English professor John Colburn, part-time director of student activities from 1953 until 1968, presides at his first Student Recognition Day, 1953.

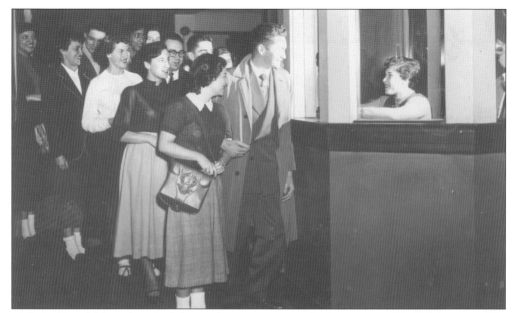

Tickets are sold for a drama club production in the Suffolk Theatre, 1955. The university's first theater troupe, the Suffolk Players, was formed in November 1936. Today the college includes the full-fledged Suffolk University Theatre Department, boasting award-winning faculty and students.

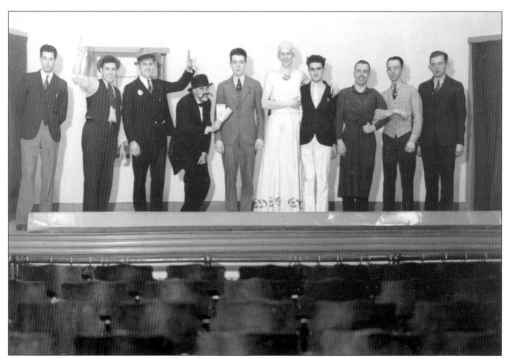

This is a rehearsal for a production featuring an all-male cast.

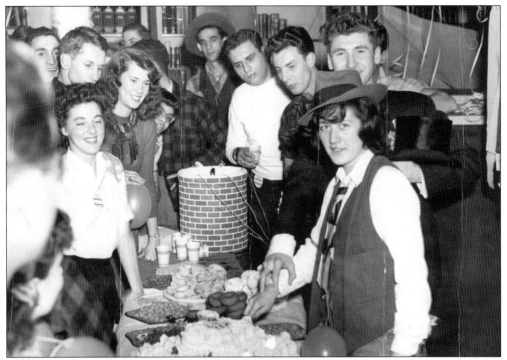

A Hobo Dance, held in the library, was one of the first great postwar social successes at Suffolk.

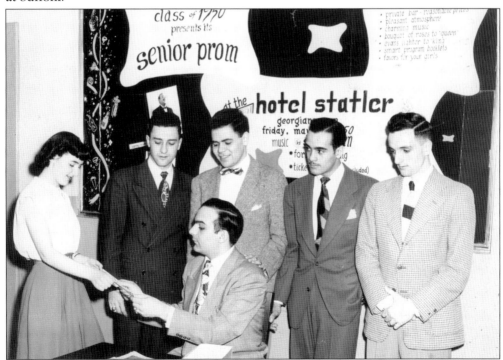

Shown here are ticket sales for Suffolk University's senior prom, in the Georgian Ballroom at the Hotel Statler, 1950.

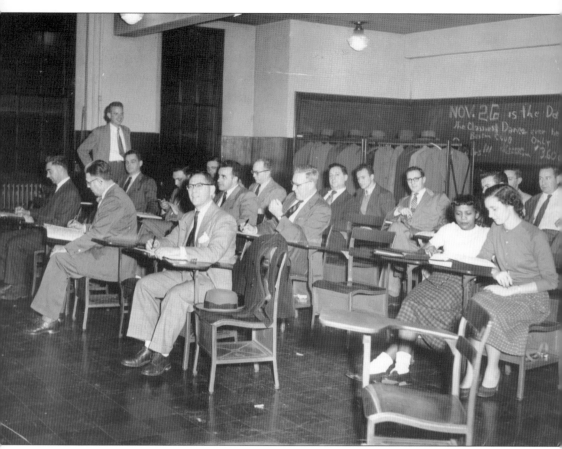

A Suffolk University Law School evening class is pictured here around 1957. The note on the blackboard announces the "classiest dance ever held at S.U.," scheduled for the Boston Club, with tickets sold at $3.60 per couple!

Donald W. Goodrich became college registrar in 1947, at a time when a flood of new students entered under the GI Bill. He served as college dean from 1956 to 1969, introducing new courses, expanding the faculty, and getting it involved in decision-making. He was given the added title of vice president in 1966.

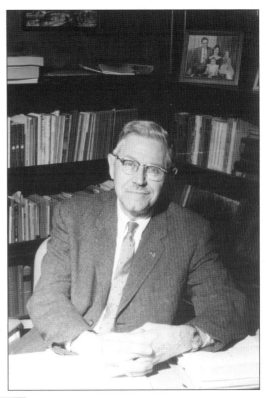

Students gather on the front steps of what was then known as the University Building, 1957. At that time, the 20 Derne Street structure was the institution's one and only building. In 1971, it was renamed the Archer Building in honor of founder Gleason Archer and his brother Hiram, a faculty member and trustee who served the university until his death in 1966.

53

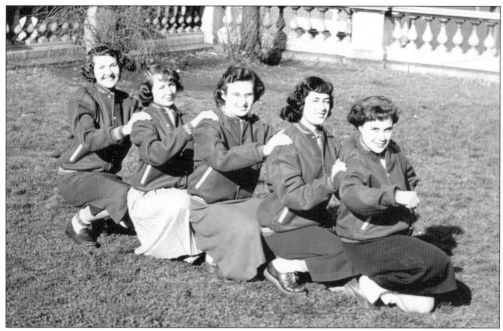

A Suffolk cheerleading squad was first organized in 1948. This picture of the cheerleaders, on the Massachusetts State House lawn, is from 1957.

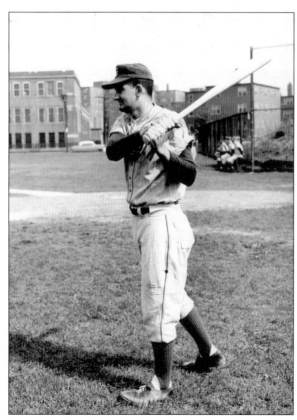

Suffolk baseball teams have distinguished themselves for 60 years without ever playing a home game on the Suffolk campus. This 1957 photograph is from, of course, an away game.

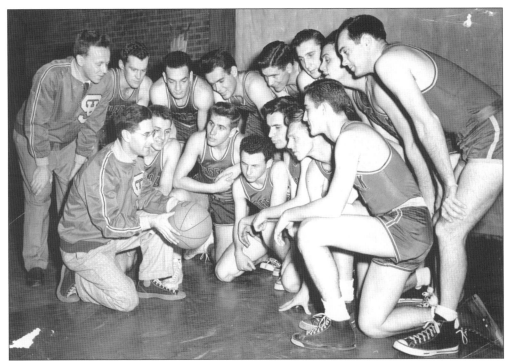

Head basketball coach and athletics director Charlie Law strategizes with his Suffolk varsity men's basketball team, 1959.

The Suffolk Journal was founded by Gleason Archer in September 1936 and has been published continuously ever since. Here sports editor "Bud" O'Brien reads the latest edition, 1956.

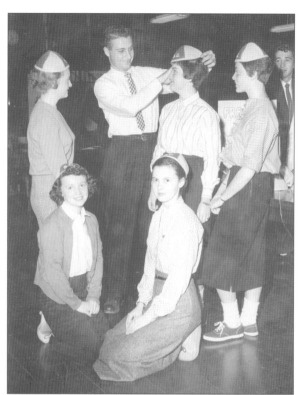

Freshmen receive their Suffolk beanies, 1958. By that date, the percentage of undergraduate women had risen from 3 percent in 1946 to about 10 percent of the student population.

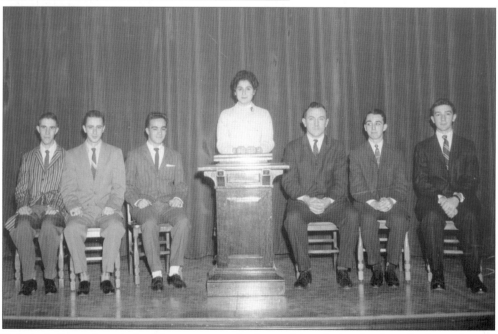

Debate is the university's oldest extracurricular activity, dating back to the law school's earliest years. A College Debating Society was set up in 1937. Allan Kennedy became director of the undergraduate forensics program in 1974, and Suffolk's debate teams have been nationally competitive ever since.

Paul Benedict, rear in a 1959 Suffolk Drama Club production, went on to a very successful acting career, becoming best known for his role as Harry Bentley on *The Jeffersons* television series, 1975–1985.

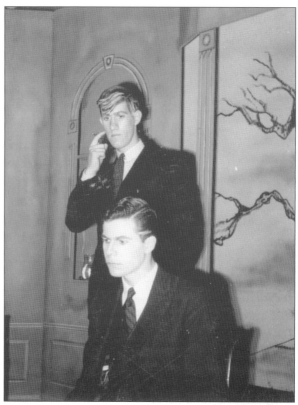

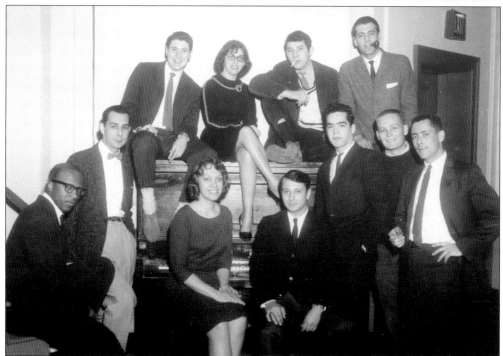

The Suffolk University Jazz Society is shown here in 1958.

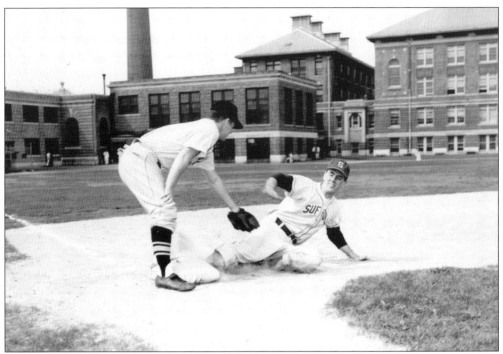

Pictured here is a Suffolk baseball game in 1961.

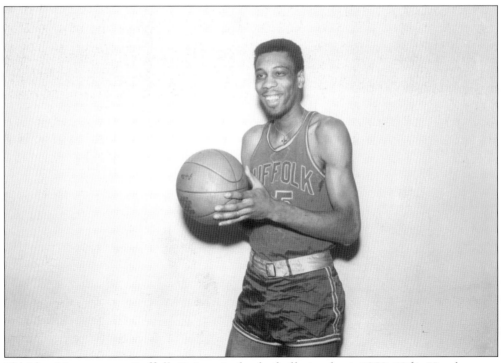

Eldridge Moore was a Suffolk University basketball standout, 1959–1961. He also was selected for the Greater Boston All-Star squad in 1961.

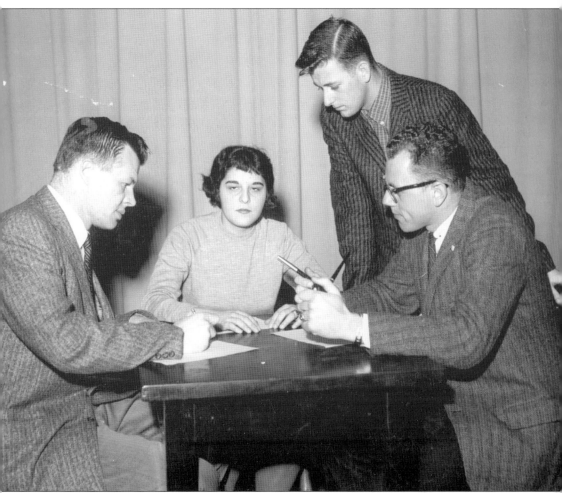

Ann Picardi was the second woman to serve as undergraduate Student Government Association president, 1959. Jeanne McCarthy had been elected to the post in 1958. The law school had set the stage when Jeanne Hession became the first woman class president in 1955. Hession also became the first woman university trustee in 1973.

In 1961, students studied wherever they could in the crowded University Building until Suffolk expanded, opening the Frank J. Donahue Building, 41 Temple Street, in 1966.

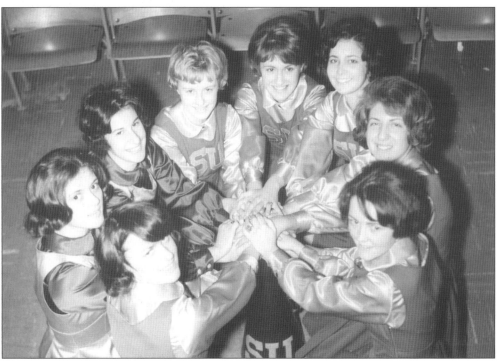

This is the cheerleading squad in the 1960s.

Freshmen proudly adorned with their beanies.

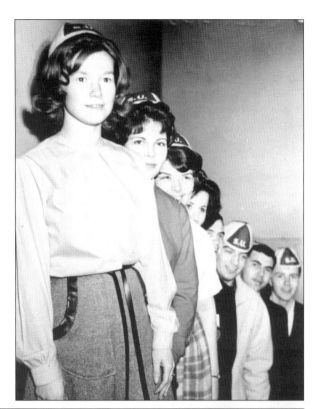

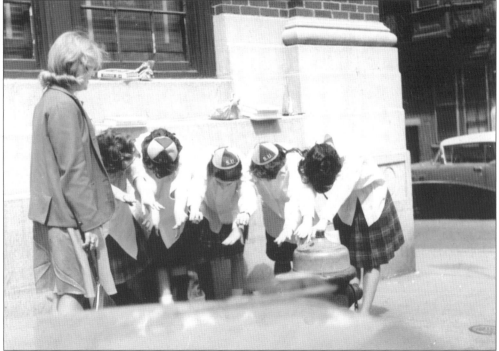

A group of freshmen wearing matching outfits and their Suffolk beanies honor a passing upperclassman, 1963.

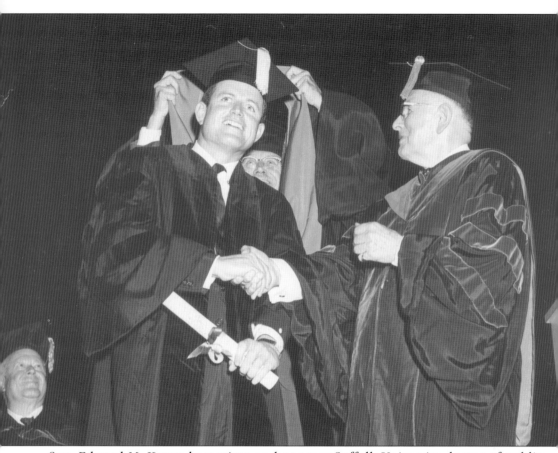

Sen. Edward M. Kennedy receives an honorary Suffolk University doctor of public administration degree, May 1964.

Students work together at the
library, 1969.

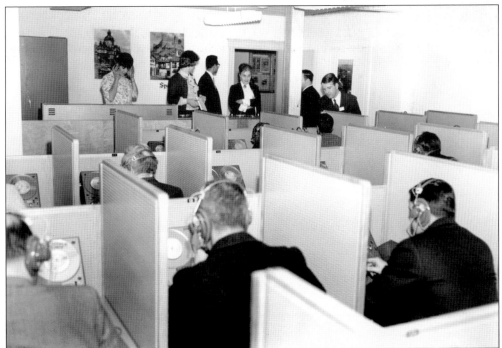

A College Language Laboratory was completed in 1965. It was renovated in 1987 and 1990,
with a satellite television dish added in the latter year to allow world-wide reception.

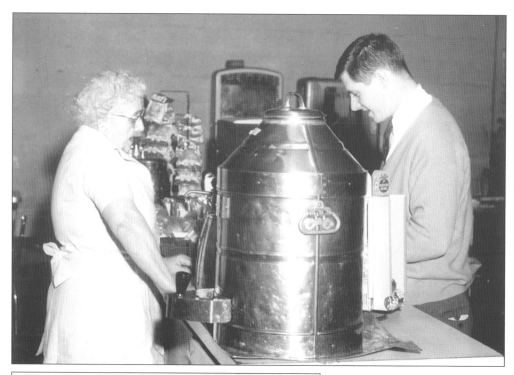

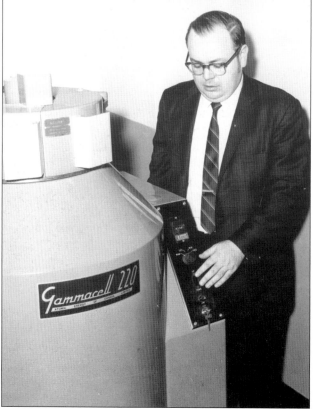

This Cold War–era coffee canister in the cafeteria might have called to mind a missile. Then again, it bears a likeness to Dean Michael Ronayne's Gammacell 220 irradiator. Some speculated that the workings of the Gammacell 220 may have mysteriously affected the taste of the cafeteria coffee.

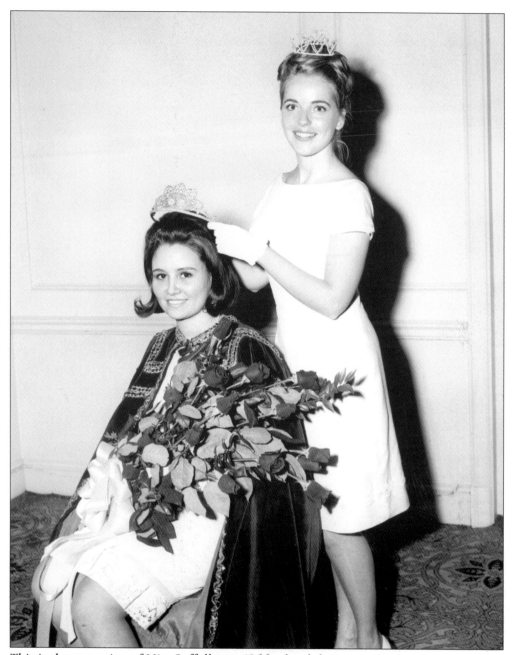

This is the crowning of Miss Suffolk at a 1966 school dance.

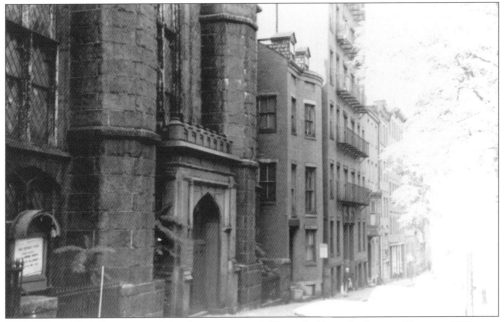

Pictured here is the First Methodist Episcopal Church, Temple Street, Beacon Hill.

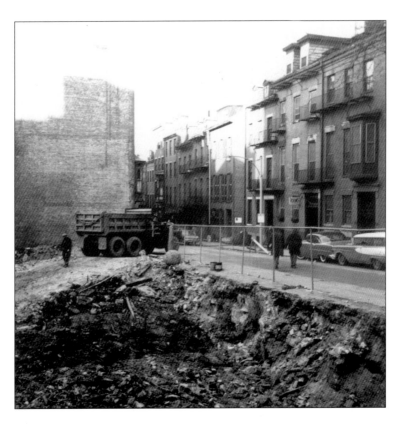

This is a view of the Donahue Building site after the First Methodist Church was razed, 1965.

The Donahue Building is shown here under construction. Originally built to accommodate general university expansion needs, it was dedicated by the trustees exclusively to law school use from 1975 until 1999.

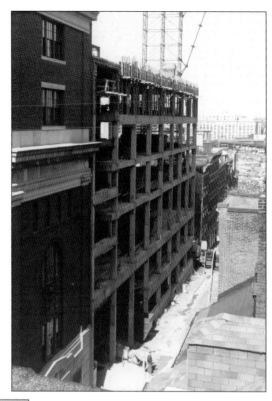

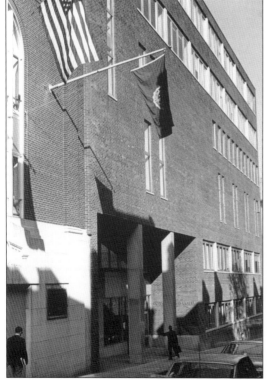

The completed Donahue Building, named for Frank J. Donahue, a law school alumnus who went on to become Massachusetts secretary of state and a leader in the Democratic party before being appointed to the Massachusetts Superior Court. He later served his alma mater as a life member of the board of trustees and university treasurer.

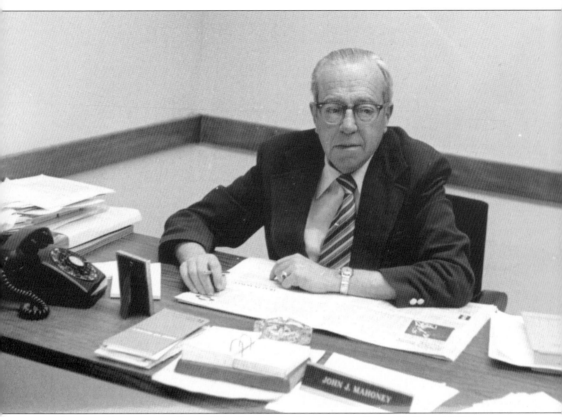

John J. Mahoney was chair of the business department from 1949 to 1967.

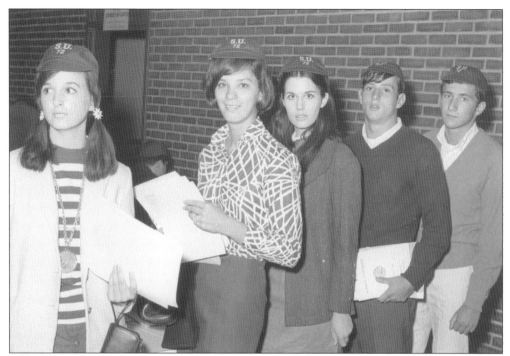

Fashion changes, and the freshman beanies have a new look in 1968.

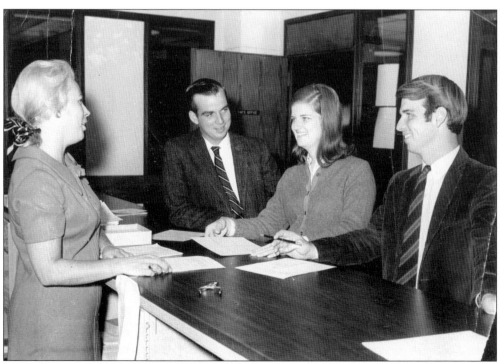

Mary A. Hefron, left, served as College of Liberal Arts and Sciences and School of Management recorder from 1963 until 1966, then as registrar from 1966 until 1997.

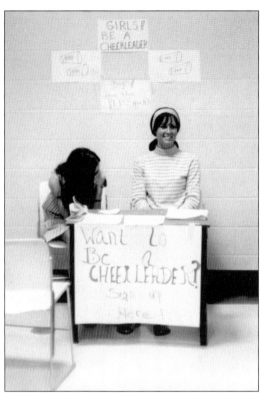

Students recruit for the cheerleading squad in 1969.

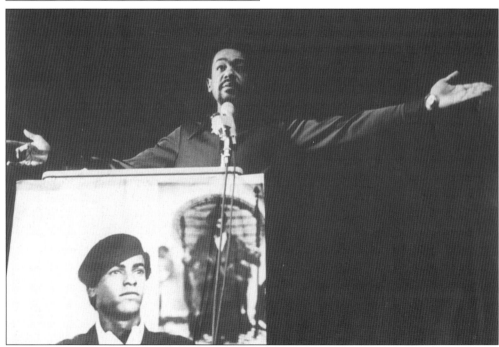

Black Panther Party cofounder Bobby Seale speaks as part of the Political Science Lecture Series. The 1960s brought social and political upheaval, which was expressed with particular strength by young people at the nation's colleges and universities.

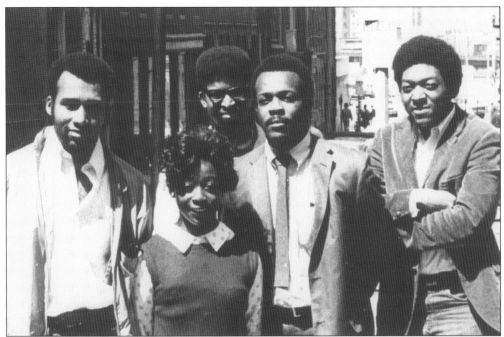

The newly founded Suffolk Afro-American Association is shown here in 1969. From left to right are Charles Olmstead, Inez Patten, Keith George, Eugene Herrington, and Richard Brown.

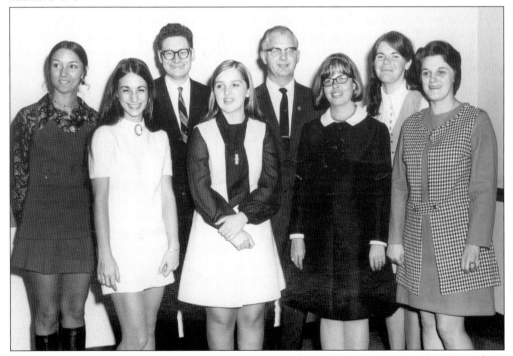

The Sigma Zeta natural science honorary society is shown here in 1970, with college dean Donald Grunewald (third from left), future biology department chair Beatrice Snow (far right), and, to her right, future chemistry department chair Maria Miliora.

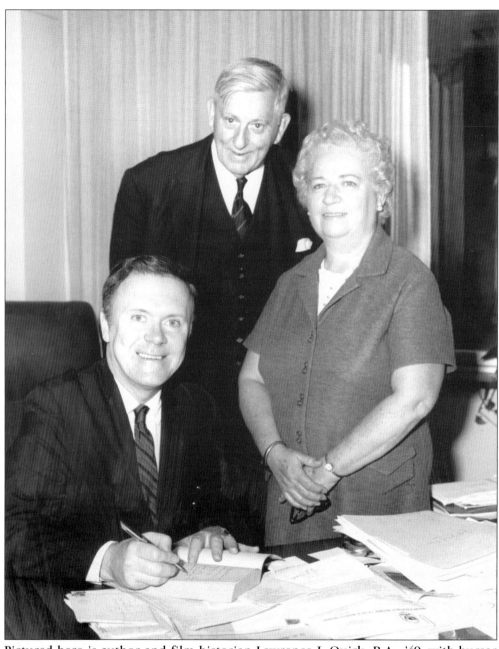

Pictured here is author and film historian Lawrence J. Quirk, B.A., '49, with bursar Dorothy M. McNamara and President John E. Fenton Sr.

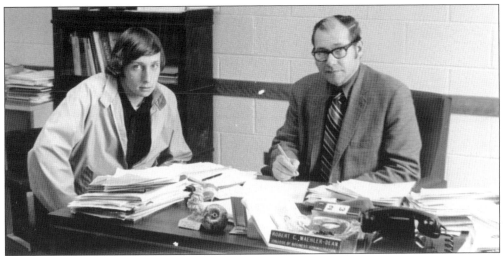

Robert C. Waehler was the second dean of the College of Business Administration from 1969 to 1974.

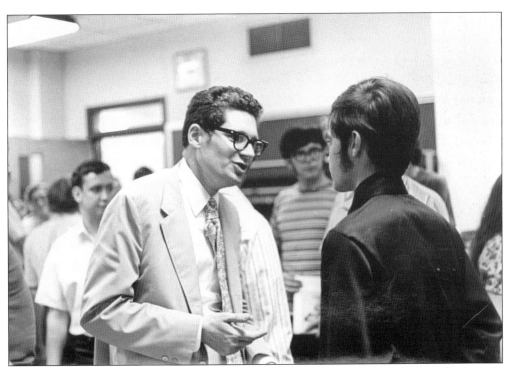

Donald Grunewald was the College of Liberal Arts and Sciences dean from 1969 to 1972. The College of Liberal Arts was renamed the College of Liberal Arts and Sciences in 1966. It was redesignated the College of Arts and Sciences in 1998 after the university's merger with the New England School of Art and Design.

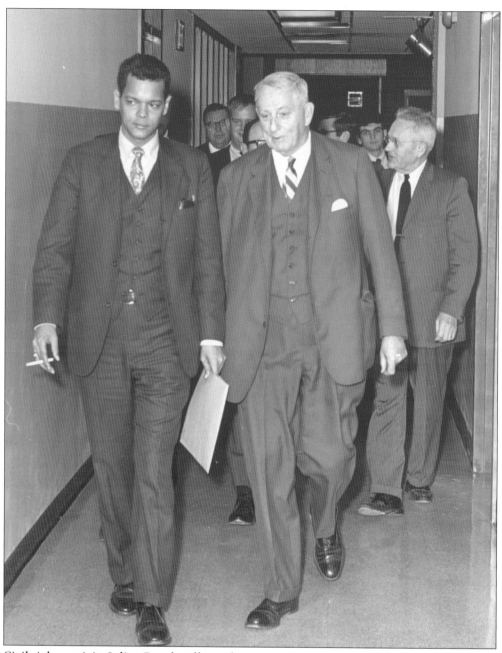

Civil rights activist Julian Bond walks with university president John E. Fenton Sr. before addressing Suffolk students in December 1969. Bond later would chair the NAACP.

Four

THE TIMES THEY ARE A-CHANGIN'

Beverly Potts was the university placement officer. Suffolk has always been dedicated to helping students find jobs and begin their road to success.

Joel Corman, who joined the College of Business Administration/Graduate School of Administration in 1967 as one of Dean Grunewald's earliest faculty appointments, began a revitalization of the master of business administration program.

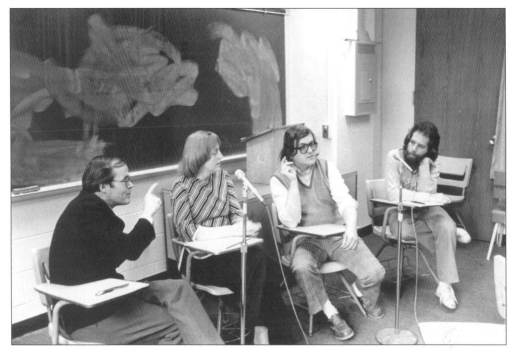

Pictured here is the colloquium on "Pressing Problems of the Universe," 1975, featuring college faculty members (left to right) John Cavanagh, history; Judith Holleman, government; Joseph McCarthy, education; and Paul Korn, psychological services.

Suffolk students respond to "Establishment" provocation, Suffolk Theatre in 1970.

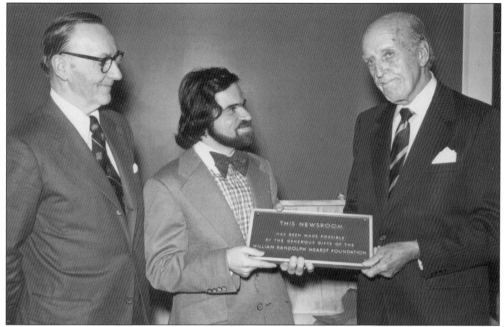

Harold G. Kern, publisher of the Hearst-owned *Boston Herald American*, visits Suffolk to provide a donation from the Hearst Foundation to support construction of a journalism newsroom for the college. Pictured with Kern (right) are Suffolk president Thomas A. Fulham and journalism department chair Malcolm Barach.

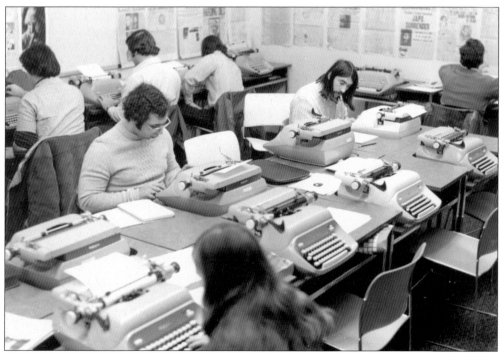

Pictured here is the journalism department classroom and newsroom, funded by the Hearst Foundation.

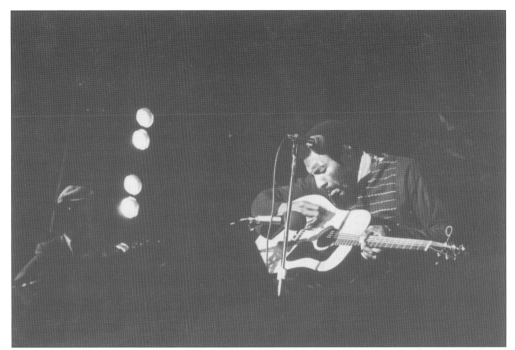

Richie Havens, who had electrified the audience as the first performer at Woodstock, plays at the Suffolk Theatre, 1972.

Buffalo Bob, from the classic 1950s children's television series *Howdy Doody*, visits the Suffolk Theatre for a 1970s revival.

"On-line" Suffolk student registration, 1970s style, is pictured here.

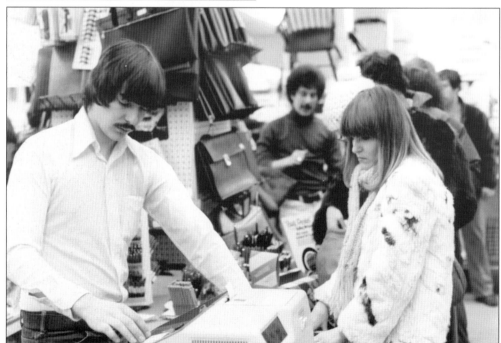

The Suffolk University bookstore, run by the Peters family, was on the ground floor of the Archer Building Annex at 51 Temple Street. In 1991, the bookstore moved to the reconstructed Ridgeway Building, facing Cambridge Street.

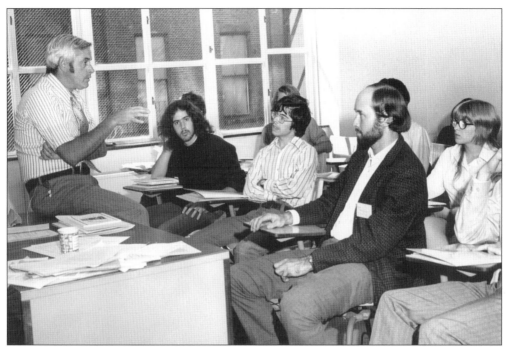

D. Bradley Sullivan, Suffolk University's first dean of students (1966–1987), consults with college faculty members, 1976.

Jim Nelson joined Suffolk in 1966 as assistant director of athletics and men's assistant basketball coach. He was named director of athletics in 1975 and was head coach of the men's basketball team from 1976 until 1995.

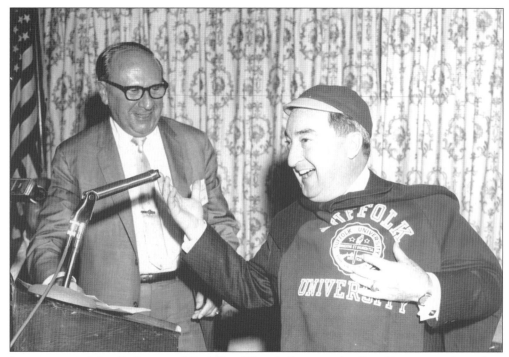

State senator John E. Powers, J.D., '68, of South Boston, the first Democrat elected as president of the state senate, visits Suffolk University, 1969.

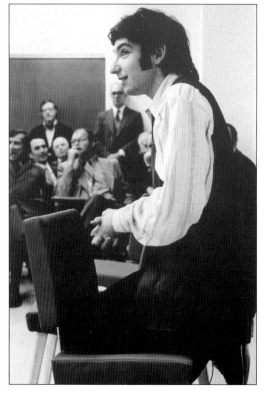

Boston Symphony Orchestra assistant conductor Michael Tilson Thomas lectures at Suffolk, 1973. Notable artists from theater, film, music, and dance have visited Suffolk and enlightened students throughout the century.

Retired Supreme Court justice Tom C. Clark appears at Suffolk for the naming in his honor of the newly founded Justice Tom C. Clark Annual Moot Court Competition, a voluntary contest for second- and third-year students, 1972.

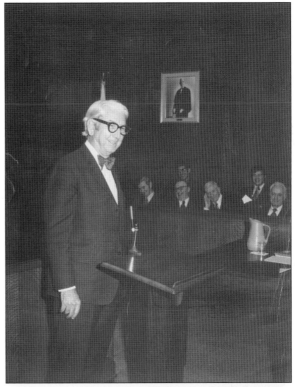

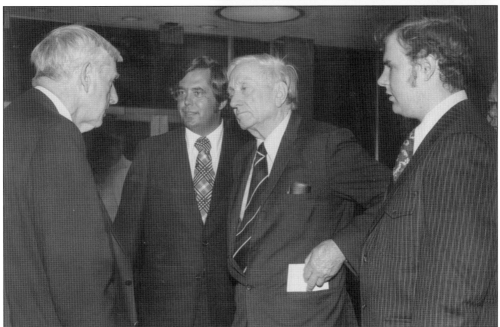

Supreme Court justice William O. Douglas, center, visits Suffolk University Law School in 1973, with trustees' chair John E. Fenton Sr., left, and newly appointed Dean David J. Sargent. At right is Richard Voke, a student at Suffolk University Law School who became chairman of the Massachusetts House Ways and Means Committee.

The annual Tau Kappa Epsilon (TKE) spaghetti dinner, to raise funds for charity, is shown here in 1973. A 20-year ban on social fraternities at Suffolk was ended in 1969 when TKE was permitted to establish a chapter at Suffolk. Later that year, Phi Sigma Sigma, the university's first social sorority, was founded.

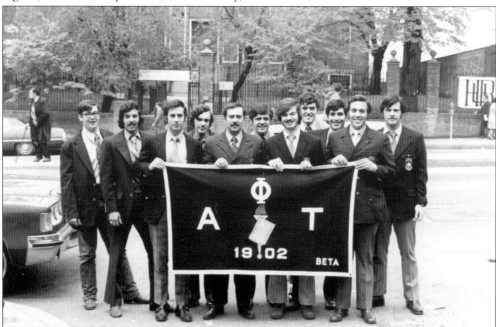

The newly founded Phi Alpha Tau service fraternity for communication arts and journalism is pictured here in 1967. The Delta Sigma Pi business professional fraternity, established in 1959, had been the first non-honorary undergraduate fraternity permitted at Suffolk University, followed in 1963 by Alpha Phi Omega, a service fraternity.

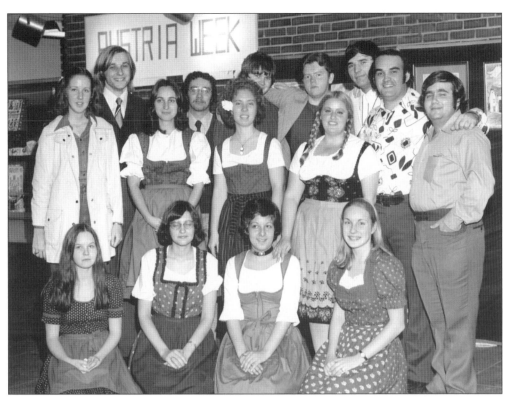

In this photograph, Suffolk undergraduates in costume celebrate Austria Week, 1972.

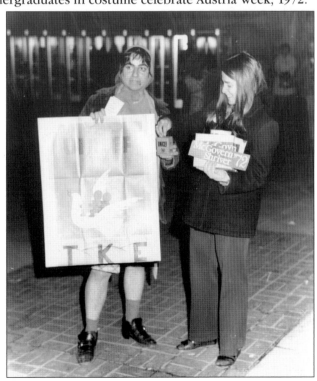

A TKE member goes trick-or-treating for UNICEF near the Park Street Subway Station in 1972, and encounters the last ghost of hope for the McGovern presidential campaign.

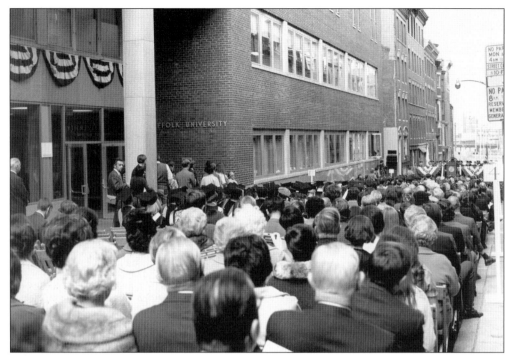

The crowd of well-wishers gathers in front of the new Donahue Building at the inauguration of Suffolk University's sixth president, Thomas A. Fulham, on Temple Street, September 26, 1971.

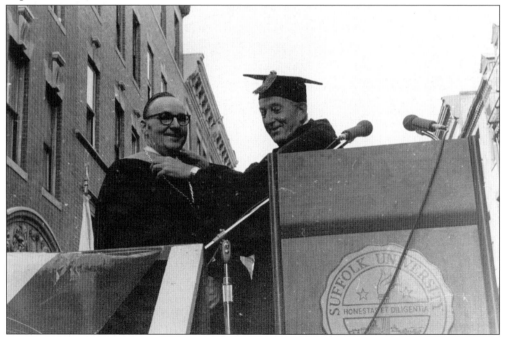

Outgoing President Fenton places the newly minted sterling silver university medallion on incoming President Fulham, 1971. The medallion has been worn by all subsequent presidents for official university ceremonies.

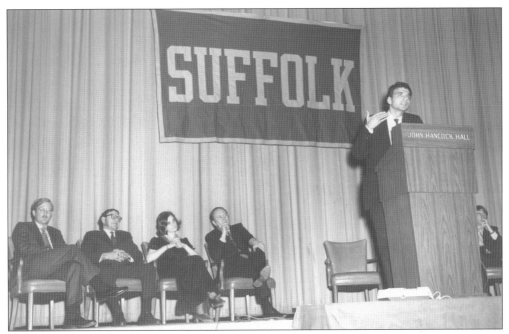

Consumer rights advocate Ralph Nader addresses a Suffolk University Law School audience at John Hancock Hall, 1972. This was one of many visits to Suffolk by Nader. On the extreme left is Student Bar Association president John C. Deliso, currently associate dean of the law school.

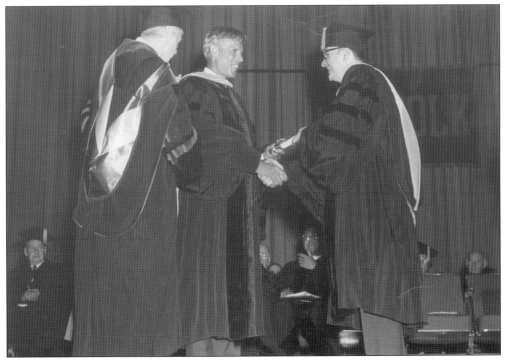

Massachusetts governor Francis Sargent receives an honorary degree at the Suffolk University commencement of 1971.

The main building at the university's marine biology field research station is shown here on Cobscook Bay, near Edmunds, Maine. The facility, established in 1968 on 40 acres donated by biology department chair Robert S. Friedman, was named in his honor in 1973.

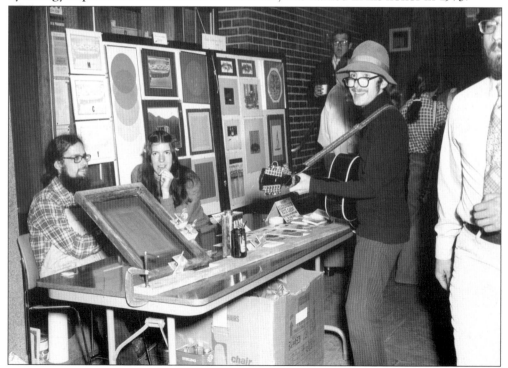

Street singer Steve Baird, one of the first to play on the Boston Common in the 1960s, visits Suffolk University, 1973.

Pictured here in a 1979 photograph is Lorraine DiPietro Cove, who continues her service as law school registrar in 2006. Cove succeeded the law school's first full-time registrar, Doris Pote, who in 1967 had replaced Catherine Judge, the law school's first separate registrar, appointed on a part-time basis in 1955.

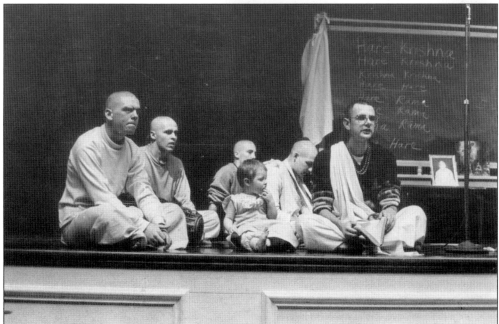

Members of the Hare Krishna sect offer enlightenment at the Suffolk Theatre, January 1971.

Vice President Francis X. Flannery, university assistant treasurer 1964–1970 and university treasurer 1970–, is pictured here.

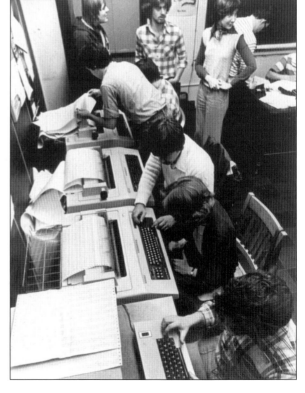

In June 1980, the School of Management approved a computer information systems (CIS) major, the first computer-related degree program to be offered by the university, and the establishment of a corresponding academic department. The John P. Chase Computer Room was dedicated in February 1983.

School of Management dean Richard L. McDowell, 1974–1991, pictured here with Sen. Edward Kennedy in 1975, greatly expanded the public management programs.

Dr. Benjamin Spock, popular baby and child care expert, offers expertise at Suffolk University, 1979.

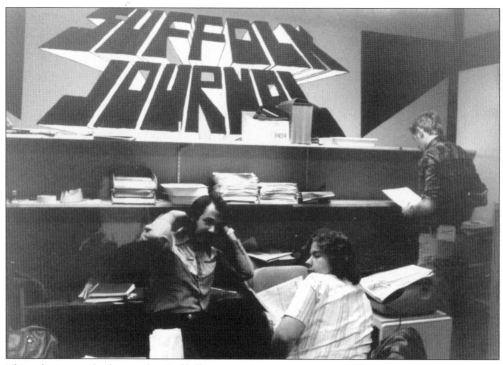

This photograph shows the *Suffolk Journal* newsroom in 1976.

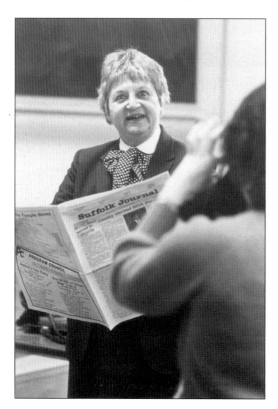

Boston Herald gossip columnist Norma Nathan, "the Eye," is amazed by gossip tidbits in the *Suffolk Journal,* 1983.

For more than 50 years, Catherine Judge has been an icon at Suffolk University Law School.

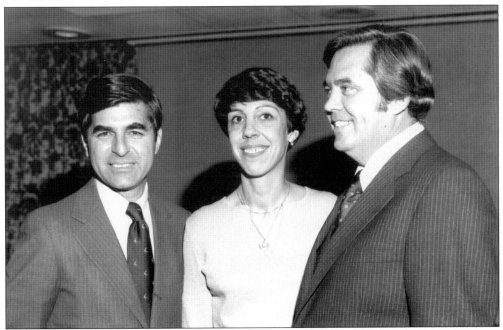

Massachusetts governor Michael J. Dukakis in 1978 with the Honorable Charlotte Anne Perretta, whom Dukakis had just named to the Massachusetts Appeals Court, and law school dean David J. Sargent are seen here. At the time, Perretta held the highest Massachusetts state judicial appointment attained by a Suffolk University Law School graduate.

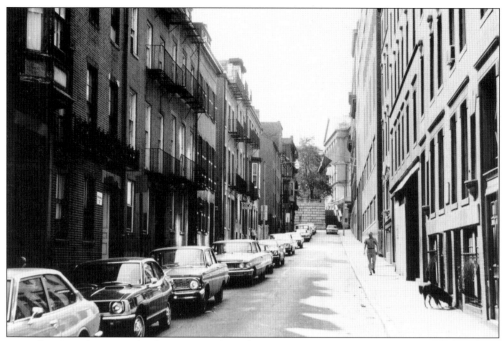

In 1969, Temple Street had narrow sidewalks and was jammed with cars.

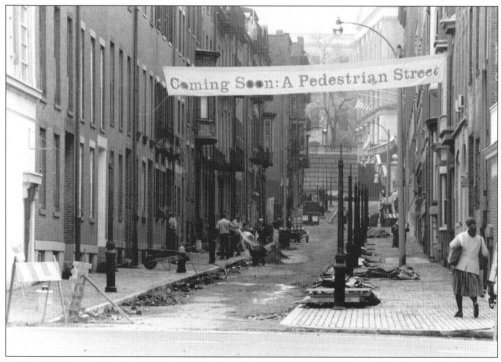

The flavor of Temple Street changed with the construction of Temple Walk, featuring gaslights and a pedestrian mall, 1977. Suffolk played a significant role in revitalizing the neighborhood.

Students head to class along the recently completed Temple Walk pedestrian mall, 1979.

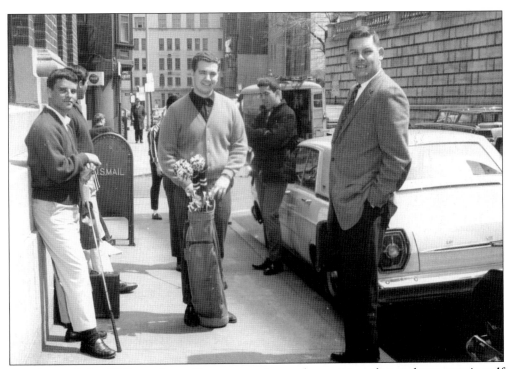

Members of the 1977 varsity golf team are shown here. An undergraduate men's golf team had been established at Suffolk in 1948, coached by athletics director Charlie Law. Varsity golf competition at Suffolk has been continuous since that time.

Associate director of undergraduate admissions Nancy Fine, director William F. Coughlin, and their colleague Martha Holmes Barrett, are pictured here in 1979.

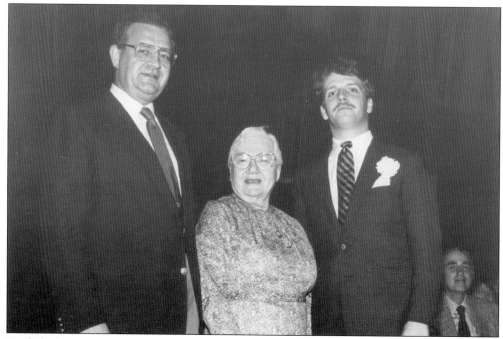

English department chair Fred Wilkins and Rosalie Warren present the Rosalie Warren Prize for English to Tom Connolly, 1983. Warren earned Suffolk bachelor's and master's degrees as a senior citizen and was a generous benefactor. Connolly would later join the English department faculty.

The College of Business Administration/Graduate School of Administration's building was at 45–47 Mount Vernon Street, 1972–1981.

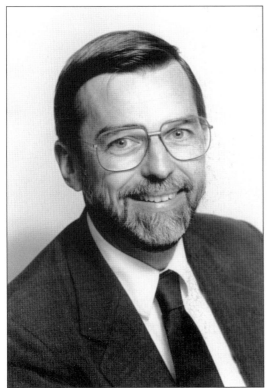

Richard L. McDowell was dean of the School of Management from 1974 to 1991. Under his leadership, graduate programs in management were expanded, and the school became the largest academic unit in the university.

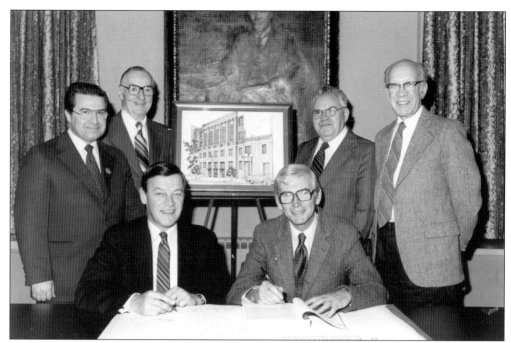

This is the signing of the contract for rehabilitation of the United Way Building, at 8 Ashburton Place, as Suffolk University's fourth principal edifice, 1980. University officials present are board chair Vincent A. Fulmer, left; President Thomas A. Fulham, left rear; and treasurer Francis X. Flannery, at table, right.

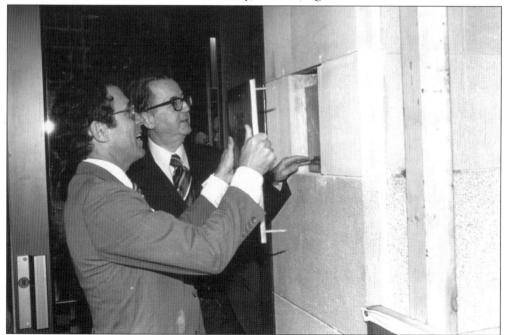

President Daniel H. Perlman and trustee Harry Zohn insert a time capsule into the cornerstone of the university's fourth principal structure, the Frank Sawyer Building at 8 Ashburton Place, at its opening on the university's 75th anniversary, Founder's Day, September 19, 1981.

Students converse near the Frank Sawyer Building, 8 Ashburton Place, the School of Management's home beginning in 1981.

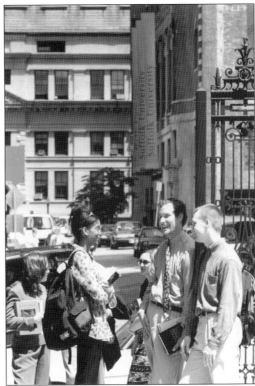

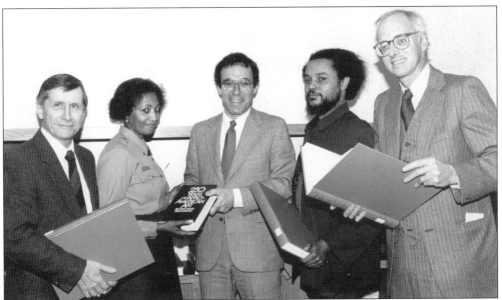

Professor H. Edward Clark, Dorothy Powell of the National Park Service, Suffolk University president Daniel H. Perlman, state representative and director of the Museum of Afro-American History Byron Rushing, and Mildred Sawyer Library director Edmund "Ted" Hamann celebrate the Collection of African American Literature at Suffolk University. Clark established the collection in cooperation with the museum, arranged to have it housed at Suffolk, and brought numerous black writers and artists to the university.

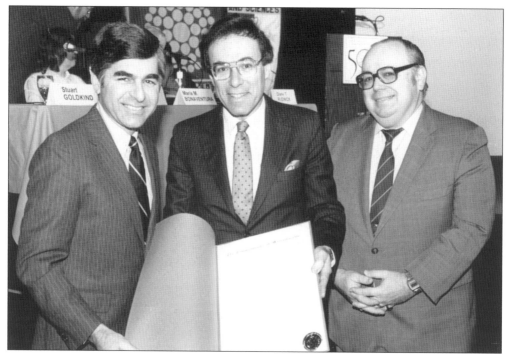

Massachusetts governor Michael Dukakis presents a proclamation to university president Daniel Perlman and College of Liberal Arts and Sciences dean Michael R. Ronayne at the 50th anniversary celebration of the university's College of Liberal Arts and Sciences, 1984.

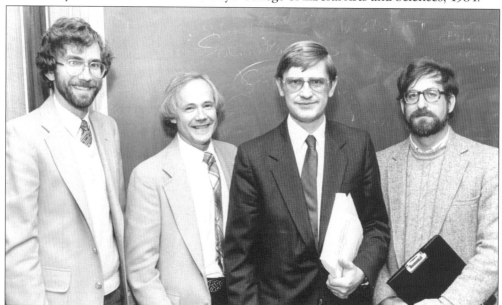

David Robbins, now associate dean for International Programs, psychology chair Robert Webb, economics chair David Tuerck, and history professor Kenneth Greenberg, the future College of Arts and Sciences dean, attend the College of Liberal Arts and Sciences 50th anniversary colloquium on "Creativity and Liberal Learning: Problems and Possibilities in American Education," organized by Tuerck, October 16, 1984.

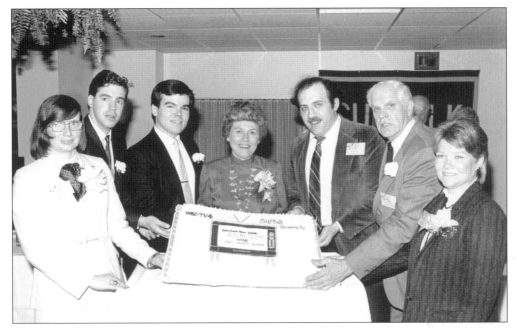

The journalism alumni group honors Shelby Scott of Channel 4 with the William F. Homer Award, named for the longtime chair of Suffolk's journalism department, 1987. From left to right are Norine Bacigalupo, Greg Beeman, Scott Reedy, Shelby Scott, Rick Saia, Lou Connelly, and Dawna Gyukeri Burrus.

Recently appointed dean of students Nancy C. Stoll (1987–) is pictured here with students at the opening of the new Student Activities Center at 28 Derne Street, September 1989.

Seventh Suffolk University president Daniel H. Perlman (1980–1989) is with law school dean David J. Sargent, who was to succeed Perlman as university president in 1989.

Five

SARGENT AND THE NEW MILLENNIUM

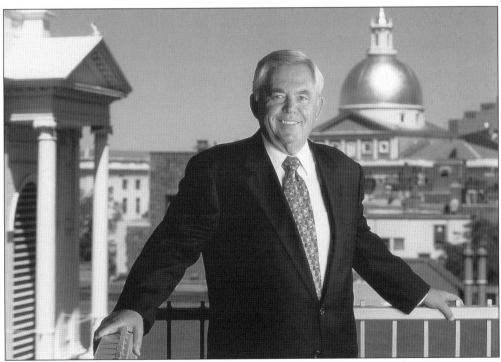

David J. Sargent, shown on the balcony of Sargent Hall, became president of Suffolk University in 1989. He graduated from the law school magna cum laude in 1954 ranked number one and president of his class. He joined the law school faculty in 1956 and became dean in 1973. During his presidency, Suffolk University has grown into a major urban university serving a student population from across the country and around the world.

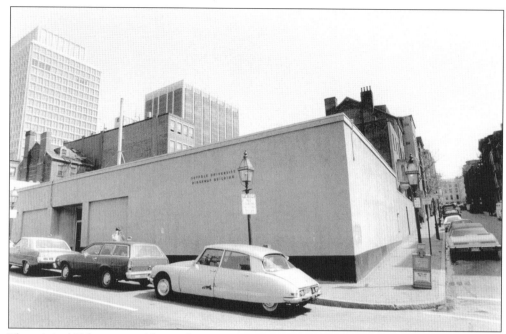

The original Ridgeway Building, a former supermarket at 148 Cambridge Street, was purchased in 1967 and was used as a student activities center until a new Student Activities Center opened at 28 Derne Street in 1989. At that time, the old Ridgeway Building was razed.

The new Ridgeway Building was constructed to house university athletic facilities, a bookstore, classrooms, and offices, opening in fall 1990. The building presents the facade of two townhouses and completely conceals a full-sized gymnasium cleverly hidden in the structure's deep basement. The gymnasium opened in February 1991.

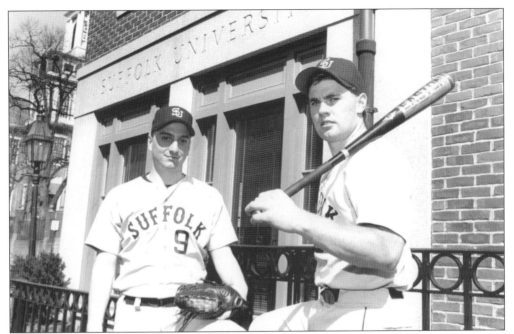

Suffolk baseball teammates Marty Nastasia and Tim Murray are shown here outside the new Ridgeway Building, 1992. The 1992 team, coached by Joe Walsh, compiled a 21–12 record and earned an Eastern College Athletic Conference tournament invitation, the first of three in a four-year period (1992–1995).

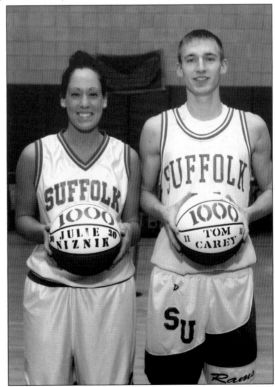

Julie Niznik and Tom Carey join the 1,000-point club. The Suffolk basketball standouts each surpassed the benchmark in February 2003.

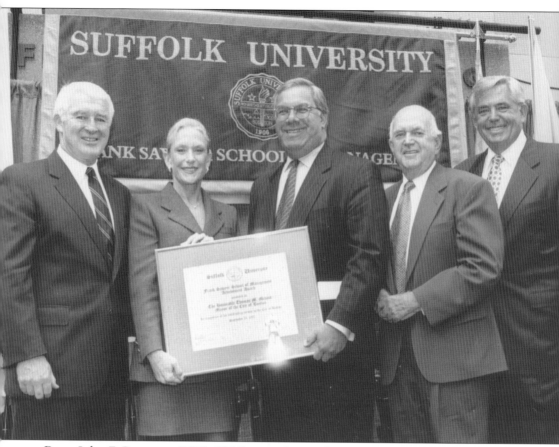

Dean John F. Brennan (1991–2001) presides, with trustee Carol Sawyer Parks, Mayor Thomas M. Menino, trustees' chair James F. Linnehan, and President David J. Sargent, over the dedication in 1995 of the School of Management as the Frank Sawyer School of Management.

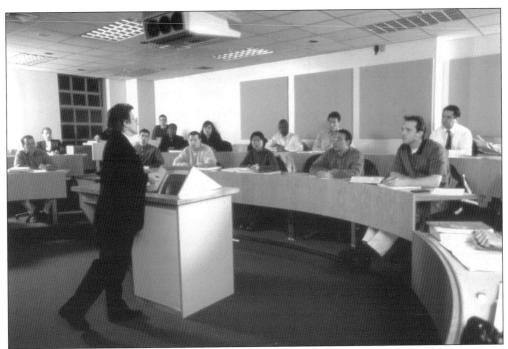

Today's classrooms have come a long way from Gleason Archer's living room in 1906. Today faculty teach in multimedia case-style classrooms in the Sawyer School of Management.

Information systems and operations management professor Jonathan Frank teaches in a high-tech classroom in the Frank Sawyer Building.

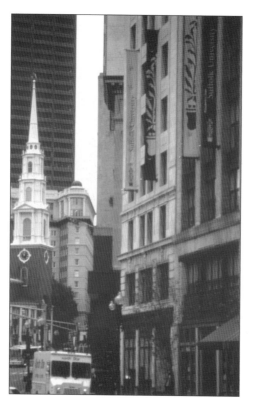

The university opened its first residence hall at 150 Tremont Street in 1996, renovating an existing building to accommodate more than 400 students. Adding student housing eased residential and traffic pressure in the Beacon Hill neighborhood and helped jump-start the renaissance along Tremont Street.

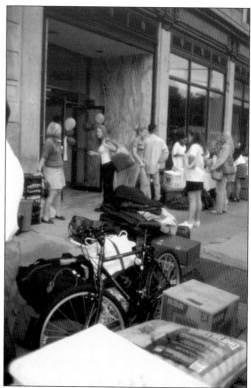

This is moving day for Suffolk's first resident students, September 1996.

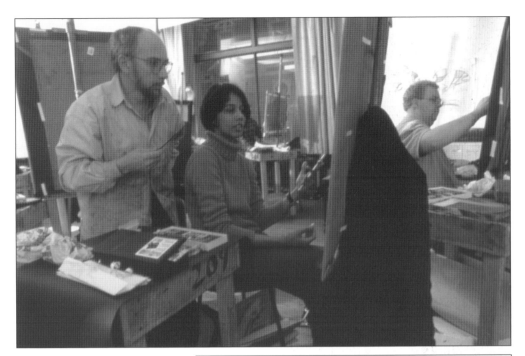

Faculty and students are at work in the studios of the New England School of Art and Design at Suffolk University, or NESADSU. The New England School of Art and Design merged with the university in the spring of 1996. It was founded as the New England School of Art in 1923 and prepares students for professional careers in art and design.

THE NEW ENGLAND SCHOOL OF ART& DESIGN SUFFOLK UNIVERSITY

Student activities director Donna Schmidt, President David Sargent, student Mark DiFraia, and friends celebrate Suffolk University's 90th anniversary in the lobby of the Frank Sawyer Building, 1996.

University alumna Diane Modica, Vice President Marguerite Dennis, Dorothy McNamara, and Rosalie Warren are on the stage at Suffolk University's 90th anniversary gala, September 19, 1996.

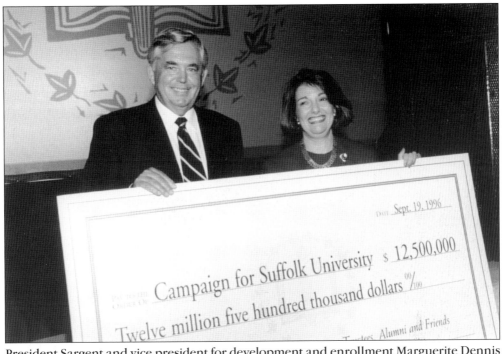

President Sargent and vice president for development and enrollment Marguerite Dennis celebrate the success of the initial phase of the 90th anniversary "Campaign for Suffolk University" fund-raising initiative.

The university family—alumni, faculty, staff, administrators, students, and friends—fill Pemberton Square to celebrate the 90th anniversary.

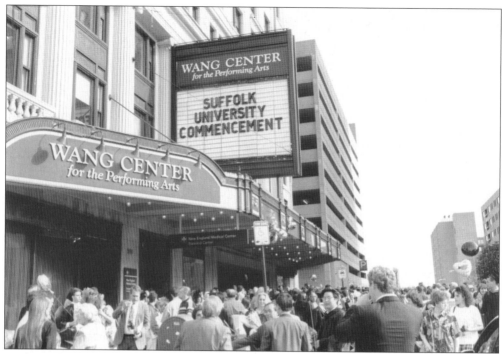

By the mid-1990s, the university had outgrown many host facilities for commencement. The Wang Center for the Performing Arts was the site of commencement ceremonies in 1996.

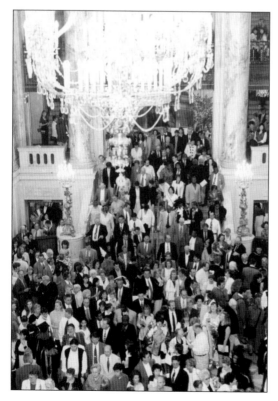

A crowd of family members fills the Wang Center lobby for commencement. As the university has grown, it has explored various venues for its commencement exercises, including the Hatch Memorial Shell, the Hynes Convention Center, the onetime Boston Garden, and the Bank of America Pavilion on the waterfront. Beginning in 2005, separate commencement ceremonies have been held for college graduate students, business school graduate students, undergraduates, and law school students.

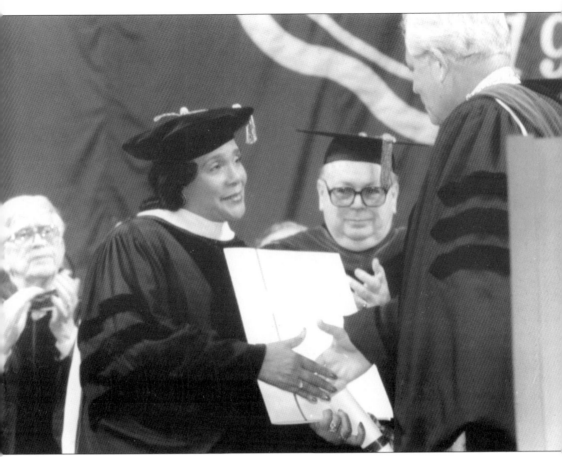

Civil rights leader Coretta Scott King receives an honorary degree, 1997.

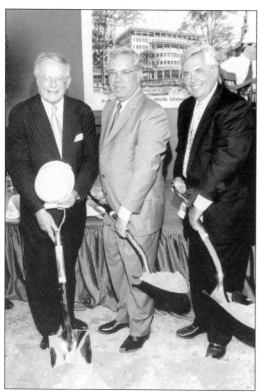

Dean John E. Fenton Jr., Mayor Thomas Menino, and President David Sargent at the groundbreaking for the new law school building at 120 Tremont Street, 1997.

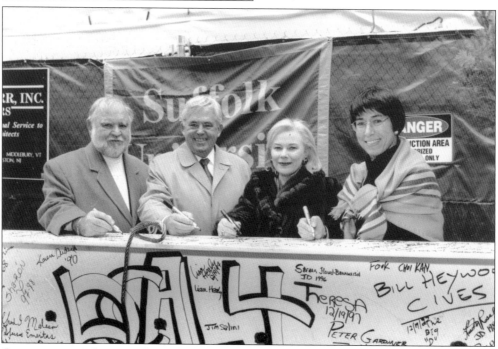

Congressman John Joseph Moakley; President David Sargent; the Honorable Marianne B. Bowler, university trustee; and Merita Hopkins, Corporation Counsel, City of Boston, sign the topping off beam for the new law school building.

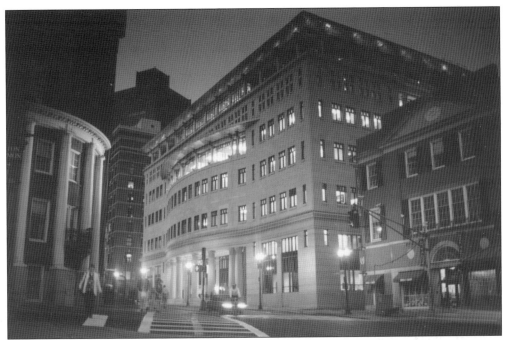

David J. Sargent Hall, the new law school building named for Suffolk's eighth president, is perhaps the finest law school building in the United States. It was designed as the most advanced and technologically sophisticated law building in the country.

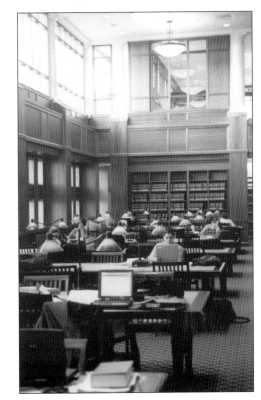

The new law school's library features reading rooms with Internet access at each seat, 1999.

Students congregate on the grounds of Suffolk's Madrid campus, founded in 1995. Suffolk-Madrid offers a broad range of courses, extracurricular activities, and dual degrees and maintains an affiliation with Universidad San Pablo-CEU, an acclaimed private Spanish institution.

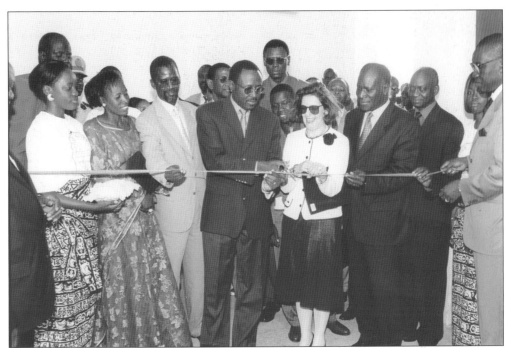

Pictured here cutting the ribbon opening Suffolk University's Dakar campus are Senegalese prime minister Mamadou Lamine Loum, Suffolk vice president Marguerite Dennis, and Senegalese minister of education André Sonko.

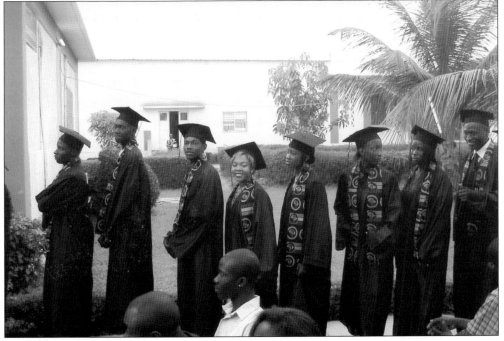

Commencement in Dakar is seen in this photograph. Students may complete a four-year degree with two years study at Suffolk-Dakar and Suffolk-Boston or choose to transfer to an American university after completing two years of study in Dakar.

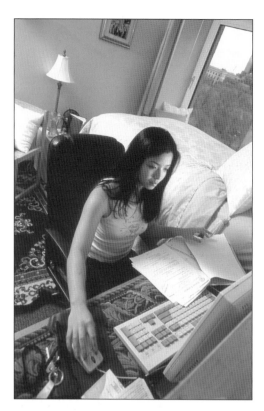

A student works in a cozy dormitory room in the Nathan R. Miller Residence Hall. Suffolk's second residence hall, at 10 Somerset Street, opened in August 2003 and houses 345 students.

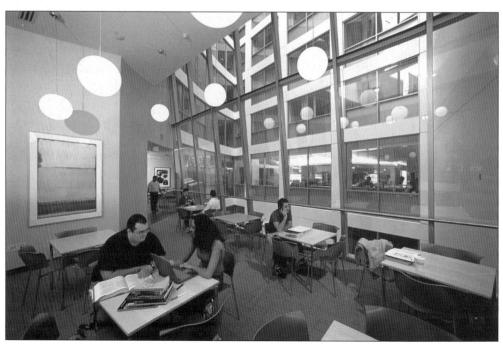

A top-to-bottom glass atrium brings light into the center of the 19-story Miller Residence Hall. The building was constructed using environmentally responsible design elements.

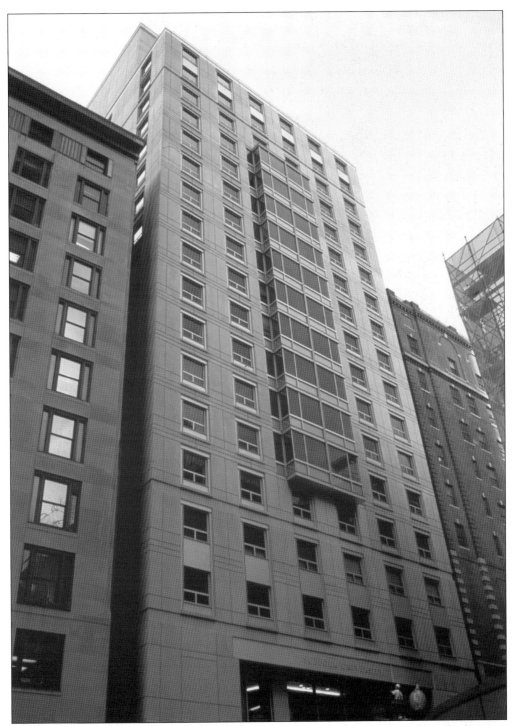

The Nathan R. Miller Residence Hall is named for a Suffolk University friend who, as a child growing up on Beacon Hill, spent much of his time at the Burroughs Newsboys Foundation. The social center, with the motto "Strive. Serve. Save. Study," stood on the site of the residence hall.

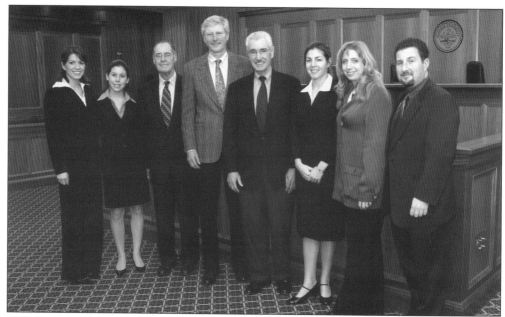

Suffolk's team reached the semifinals in the National Moot Court Competition, November 2004. Law team members, judges, and coaches gathered here at Suffolk University Law School include Kristin Ferris, J.D., '05; Lauren Koblitz, J.D., '05; the Honorable Edward Harrington, U.S. District Court; Dean Robert H. Smith; Thomas Horgan, Boston Municipal Court; Suzanne Breselor, J.D., '05; Legal Practice Skills instructor Julie Baker; and Stuart Hurowitz.

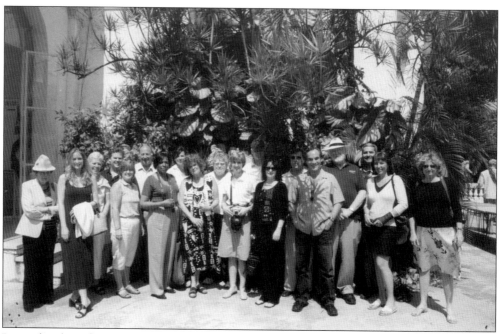

Law school professors Catherine Judge and Charles Kindregan, Judge Isaac Borenstein, and clinical professor Ilene Seidman join lawyers and judges from across the United States in a visit to Havana to learn about the Cuban legal system, March 2004.

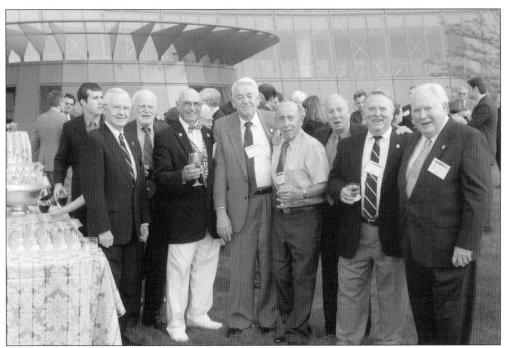

Shown here is a law school alumni reunion at the Moakley Federal Courthouse named for Congressman Joe Moakley, a graduate of the law school and trustee of the university.

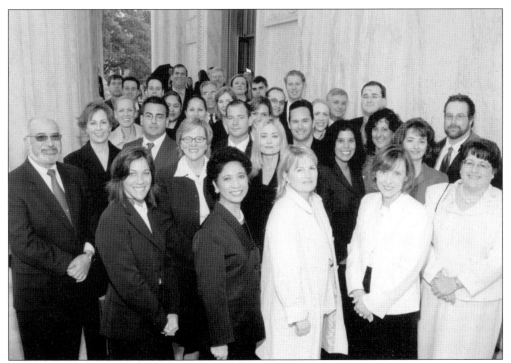

Suffolk University alumni sponsored by Dean Robert Smith were sworn before the Bar of the U.S. Supreme Court, Washington, D.C., in May 2004.

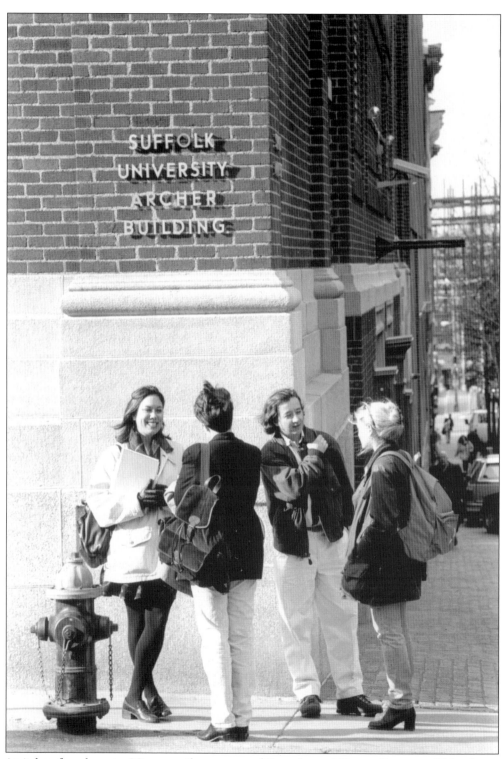

As it has for close to 90 years, the corner of Temple and Derne Streets still beckons students during class changes. Students meet friends outside the Archer Building.

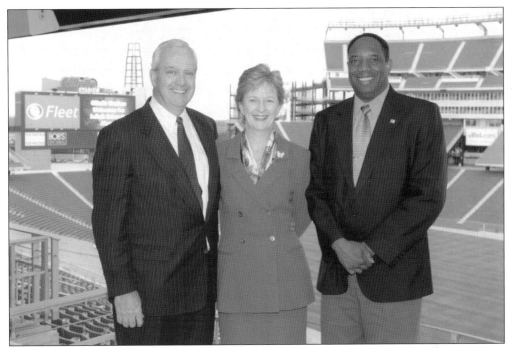

Sawyer School of Management dean William J. O'Neill Jr.; Kathryn Battillo, vice president for advancement; and Ralph Mitchell, Sawyer Business School alumni-trustee, are shown here at Gillette Stadium for an alumni event.

Pictured here is the lobby of the Rosalie K. Stahl Building at the corner of Tremont and Beacon Streets, the newest building on Suffolk's Boston campus. The building houses administrative offices and the the new Mildred F. Sawyer Library, which serves the college and the business school.

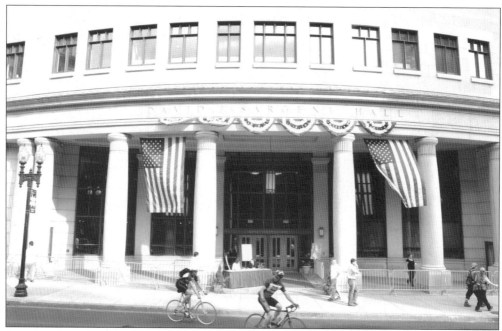

David J. Sargent Hall is bedecked in red, white, and blue during the 2004 Democratic National Convention. The university was in the thick of the excitement, with convention-goers seeing a special exhibit and attending Democratic National Convention events and symposia on campus.

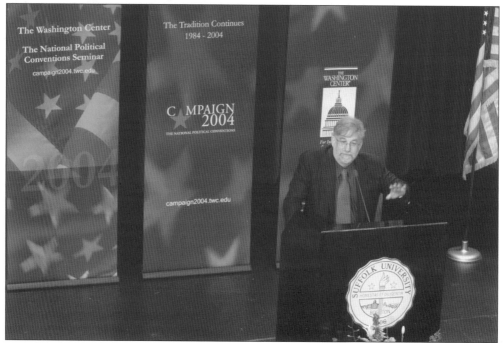

College of Arts and Sciences dean Kenneth Greenberg greets Washington Center for Internships and Academic Seminars program participants during the 2004 Democratic National Convention.

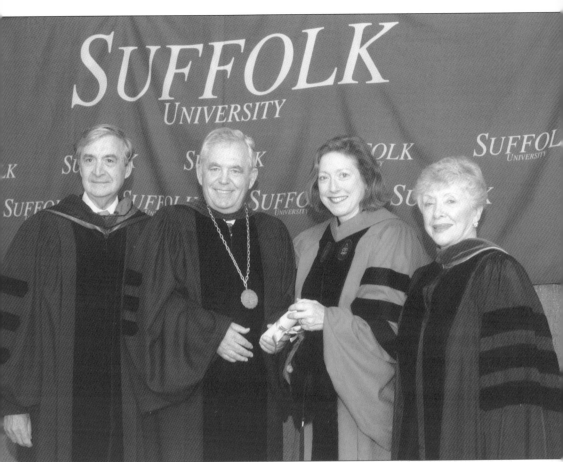

Suffolk Board of Trustees chair Nicholas Macaronis and President David Sargent are seen here at the 2004 law school commencement with honorary degree recipient Stanford Law School dean Kathleen M. Sullivan and trustee Dorothy A. Caprera. The year 2004 marked the 50th anniversary of the class of 1954, in which both Macaronis and Sargent graduated.

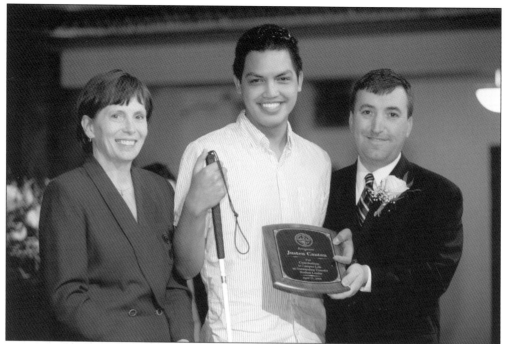

Provost Patricia Maguire Meservey and student activities director Aurelio Valenti present Justen Canten, center, with the Outstanding Transfer Student Leader Award, April 2006.

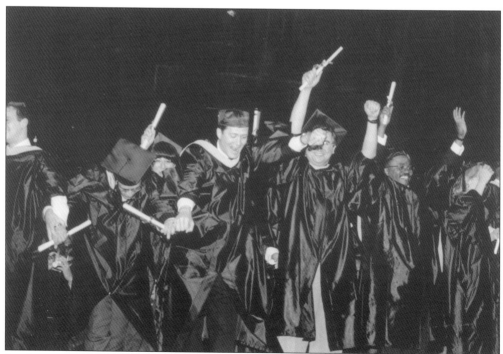

Students whoop it up at commencement, 2005.

The university celebrates New Year's Eve 2006 with festivities featuring a First Night ice sculpture on Tremont Street, setting the stage for the beginning of Suffolk's Centennial Celebration in September 2006. Shown here is university archivist Beth Bower with her nephew A. J. Cattalano.

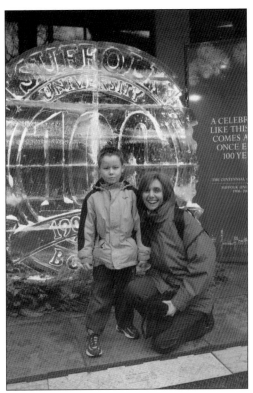

As Suffolk University's centennial year unfolds, the celebration begins with an eye on its last 100 years and the promise for its next century of excellence.

ACROSS AMERICA, PEOPLE ARE DISCOVERING SOMETHING WONDERFUL. *THEIR HERITAGE.*

Arcadia Publishing is the leading local history publisher in the United States. With more than 3,000 titles in print and hundreds of new titles released every year, Arcadia has extensive specialized experience chronicling the history of communities and celebrating America's hidden stories, bringing to life the people, places, and events from the past. To discover the history of other communities across the nation, please visit:

www.arcadiapublishing.com

Customized search tools allow you to find regional history books about the town where you grew up, the cities where your friends and family live, the town where your parents met, or even that retirement spot you've been dreaming about.